ON DRAWING

FOURTH EDITION

ON DRAWING

FOURTH EDITION

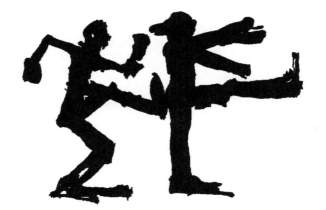

Roger Winter

ROWMAN & LITTLEFIELD PUBLISHERS, INC.
Lanham • Boulder • New York • Toronto • Plymouth, UK

ROWMAN & LITTLEFIELD PUBLISHERS, INC.

Published in the United States of America
by Rowman & Littlefield Publishers, Inc.
A wholly owned subsidary of The Rowman & Littlefield Publishing Group, Inc.
4501 Forbes Boulevard, Suite 200, Lanham, Maryland 20706
www.rowmanlittlefield.com

Estover Road
Plymouth PL6 7PY
United Kingdom

British Library Cataloguing in Publication Information Available

Library of Congress Cataloging-in-Publication Data:

Winter, Roger, 1934–
 On drawing / Roger Winter. — 4th ed.
 p. cm.
 ISBN-13: 978-0-7425-5915-8 (cloth : alk. paper)
 ISBN-10: 0-7425-5915-7 (cloth : alk. paper)
 ISBN-13: 978-0-7425-5916-5 (pbk. : alk. paper)
 ISBN-10: 0-7425-5916-5 (pbk. : alk. paper)
 1. Drawing—Study and teaching. 2. Drawing—Technique. I. Title.
NC590.W56 2008
741—dc22 2007031634

Printed in the United States of America

⊗™ The paper used in this publication meets the minimum requirements of
American National Standard for Information Sciences—Permanence of Paper
for Printed Library Materials, ANSI/NISO Z39.48-1992.

To Robert Birmelin and Seymour Leichman
for reawakening my interest in drawing

CONTENTS

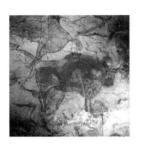
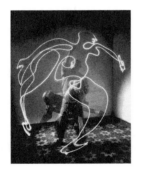

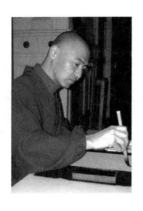

CHAPTER FOUR: Drawing and Writing 37

CHAPTER FIVE: Geometry 49

PREFACE

This book is a major departure from its previous editions. Much has been added, subtracted, and rearranged in an effort to meld historical insights with an open eyed view of drawing at this complex moment in time.

The definition of drawing has been stretched and pushed to the point where a work is often recognizable as drawing only because an artist or curator insists that it is. The skill once associated with drawing is now sometimes seen as a curse to be exorcised as quickly as possible in order to free the mind from the hand. At the same time, some artists and teachers still promote the skill-based values of older European cultures. But neither the vagaries of fashion nor Eurocentric nostalgia represent the last word to an artist looking for a voice in our global dialogue.

Whatever the philosophical bent, drawing requires a constantly active state of mind—a vigor so unlike the popular conception of drawing as a refined pastime. Some books on drawing lay out a step-by-step method meant to prevent failure, but the user will soon learn that it also prevents success. The best that a safe approach can do is to habituate an artist's work into perpetual mediocrity. Art cannot be made in safe havens.

The worthwhile drawing process takes a hazardous route guided by the most general of concepts and goals. Sometimes a drawing ends in disaster, and sometimes it is brilliantly successful, and the final combination of bold decisions and subtle suggestions that make up the successful work are born, in large part, of subjective, spontaneous discovery. The exercises suggested in the appendix of this book are, for the most part, well known, but they will not translate into a method that moves from A to Z in rational steps. And this is as it should be. It's not through a system, but rather through the gamble, the willingness to take risks, to make mistakes, that we keep our work alive and growing.

It is not the strongest of the species that survive, nor the most intelligent, but the ones most responsive to change.
—CHARLES DARWIN

The great myths show that when you follow somebody else's path, you go astray. The hero has to set off by himself, leaving the old world and the old ways behind. He must venture into the darkness of the unknown, where there is no map and no clear route.
—KAREN ARMSTRONG

The expertise and effort of many, many people went into the making of this book, and I am grateful for all the generous help I received. I especially wish to thank my editor, Ross Miller, his assistant, Ruth Gilbert, and all the other members of the staff at Rowman & Littlefield for their painstaking care in the development and production of this book. I also thank the museums, galleries, private collectors, artists, and others who permitted me to reproduce the works used as illustrations, and also the writers for their quotes used throughout the book. Thanks to the many former students whose work I have relied upon as a source of illustrations; the photographers for their valuable help; the people who appear in photographs; those who helped me translate letters, find addresses, and send permission requests; those who critiqued my ideas; and all the others who were supportive, indulgent, and patient in so many ways. I especially wish to thank Judythe Sieck for her creative role in the design of this book.

CHAPTER ONE
A BRIEF HISTORY

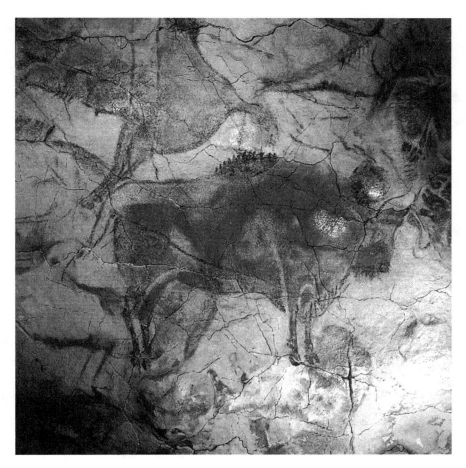

"Drawing has a primal and elemental character: it enjoys a mythic status as the earliest and most immediate form of image making." —EMMA DEXTER

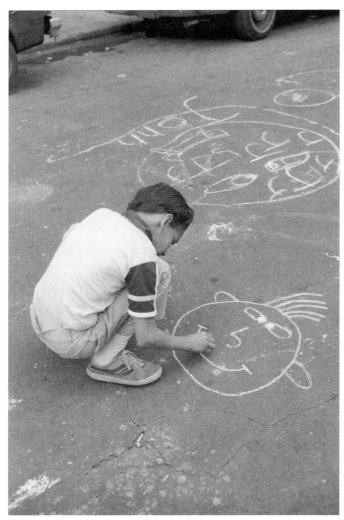

FIGURE 1.1
Photograph of boy with chalk, 1978.
(Copyright by Martha Cooper)

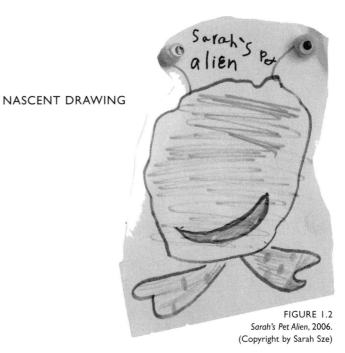

NASCENT DRAWING

FIGURE 1.2
Sarah's Pet Alien, 2006.
(Copyright by Sarah Sze)

Who teaches the child to draw? Hopefully, no one. Drawing is a form of play, a birthright. Give any child a piece of chalk and a sidewalk, and within minutes a conglomeration of symbols and images will appear as if by magic [FIGURE 1.1]. Some children draw imaginary playmates hoping they will come alive [FIGURE 1.2]. Some draw symbols of the real inhabitants of their world. But as we grow older, cultural pressures prompt us to see our naturalness, our play, as somehow unworthy. Only those who can't grow up keep contact with their original gifts.

The twentieth-century French artist Jean Dubuffet coined the expression "art brut" (raw art) to describe the artwork of children, the naïve, the primitive, the insane, and any others unaware of, or perhaps spiteful of, the rules that cultures impose. Such is the case with the work of artist Martin Ramirez, a schizophrenic who accomplished most of his extraordinary body of work during prolonged stays in hospitals [FIGURE 1.3]. Art brut, sometimes referred to as outsider art or naïve art, quite often has magical meaning. In its purest state it is made neither for profit nor fame but for personal pleasure. Based on such criteria, perhaps Dubuffet would have classified the first drawings ever made as art brut.

PREHISTORIC DRAWINGS

"Prehistory" refers to no specific block of time but rather to the time in any geographical location before the emergence of written language. Prehistory in France is far more ancient by the calendar than it is in the United States, although a new archaeological find could change these dates in a moment.

No one knows for certain why our earliest human ancestors drew. Surely thousands of drawings were made before any that is extant. What might they have been like? We can search for clues in the abundance of

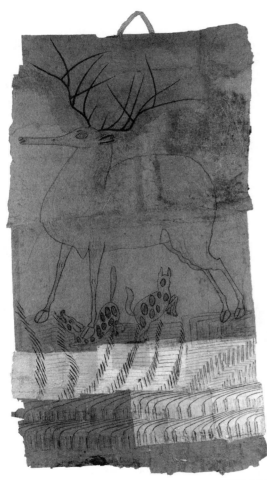

FIGURE 1.3
Untitled (stag), Martin Ramirez (1895–1963), Auburn, California, c. 1948–1963, crayon and pencil on pieced paper, 56 × 29½". Collection of Selig and Angela Sacks. (Photo by Gavin Ashworth, NY)

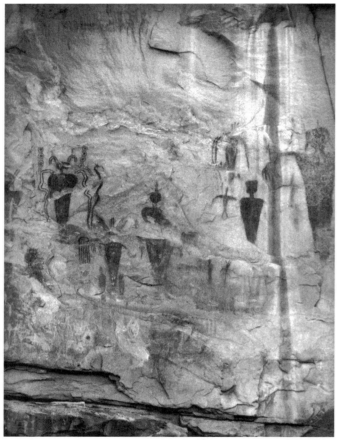

FIGURE 1.4
Photograph of pictographs from Sego Canyon, Utah.
(Copyright by Steven Jay Rudy)

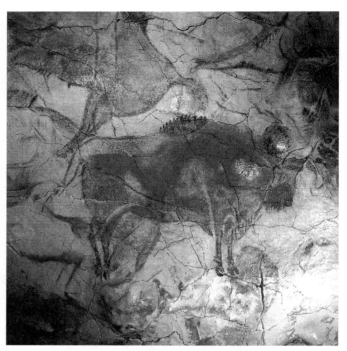

FIGURE 1.5
Bison from the polychrome ceiling, Museum of Altamira, Spain.
(Photo by Museo de Altamira and P. Saura)

examples that do exist from the cave walls in Europe to the cliff sides in western areas of North America [FIGURE 1.4] to sites in virtually every country on earth. Were these works meant to be art? Not as far as we know, and yet we have no reason to think that their makers had any less sense of what we would call the beautiful than artists in subsequent times. A bison drawn on a cave ceiling in Altamira, Spain [FIGURE 1.5], compares well

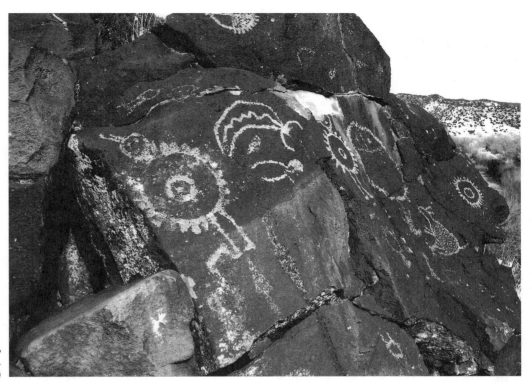

FIGURE 1.6
Native American petroglyphs, New Mexico.
(Photo by author)

in terms of formal grace with recent examples of animal drawings (see chapter six). Such works, rather than mere decoration, more likely accompanied rituals meant to cope with the mysteries and fears that surrounded human life in a hunting culture.

Most prehistoric drawings represent animals and anthropomorphic figures. However, some early people drew abstract forms: spirals, concentric circles, zigzags, sunburst patterns, etc., as symbols of migration patterns or of heavenly bodies [FIGURE 1.6]. Perhaps drawing in its early stages was used to tell stories, or to keep records. We may never know why drawing started, but this much we do know: without pencil or paper, with nothing more sophisticated than sticks to mark in the dirt and sharp stones to scratch on rocks,

our early ancestors brought drawing—the parent of writing, the parent of all the visual arts—into the world.

REPLICATION

The ancient Greeks were certainly not the first to imitate visible nature. Egyptian art is rich with examples, as is the art of sub-Saharan Africa and Mexico. But in Egypt, naturalism was a flirtation swept aside and forgotten because cultural values called for other conventions. Or in the case of the Olmecs of Central Mexico, the culture itself disappeared. Only in Greece was the art of replication sustained, perfected and passed along to other cultures. Ironically, the Greek philosophers saw nature itself as no more than a poor imitation of an idea in the mind of god, so this made imitative art an imitation of an imitation—a shadow of a shadow. In *The Republic*, Plato pronounced art to be so far removed from the truth that artists were seen as unworthy candidates for admission into his theoretical well-ordered state.

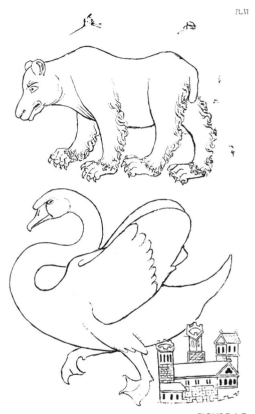

FIGURE 1.7
Bear and swan. Plate 6 from *The Medieval Sketchbook of Villard de Honnecourt.*

With the decline of Hellenistic cultural influence and the rise of Christianity, the idea of art as replication of nature was virtually forgotten and stayed underground for hundreds of years. The artists of the middle ages, considered common craftsmen, carried out the values of a culture looking for spirituality, a reality beneath the skin of nature. This subjective religious fervor often joined mathematics to achieve a static timelessness, far removed from direct perception of the visibly intelligible world. If an artist needed to draw a certain

object, he consulted a portfolio called a "pattern book" filled with acceptable depictions of a great variety of plants, animals, and architectural and mechanical details. Pattern books also included images of people dressed in costumes engaged in various activities. The best known of the pattern books was assembled by a French architect, Villard de Honnecourt [FIGURE 1.7].

Medieval cultures under the sway of Christianity remained frozen in tradition for nearly a millennium. It was not until the fifteenth-entury's rise of intellectual restlessness and scientific curiosity that artists once again became interested in rendering the surface appearance of things. Artists of this period of awakening, the Renaissance, turned to the idealized ob-jectivity of classical Greece and Rome as an evacuation route from the spiritualism of the art of the middle ages. The Renaissance, like all historical epochs, issued a call, and the call was answered by artists who were able to comprehend the temper of the time, most essentially by the creative geniuses, Raphael, Michelangelo, and Leonardo da Vinci [FIGURE 1.8]. These artists firmly established

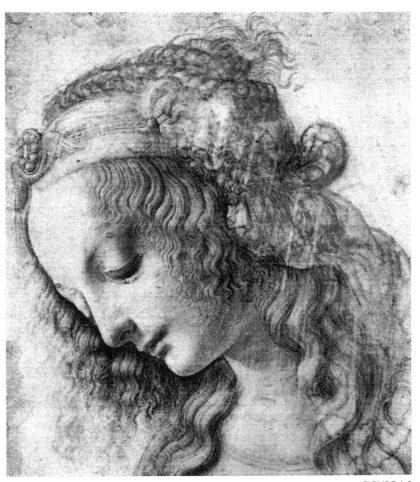

FIGURE 1.8
Drawing of a woman's head, Leonardo da Vinci.

the idea that drawing directly from nature, modified by aesthetic standards resurrected from antique sculpture, was at the very core of the visual arts. Michelangelo's famous command to his apprentice ("Draw, Antonio. Draw and do not waste time") set the theme carried forward by the newly formed art academies. The ideal of learning to replicate through drawing from nature guided the artists of Europe for more than three hundred years.

THE AGE OF DISILLUSION

During the middle decades of the nineteenth century, artists began to question the ideals of Renaissance art and the authority of art academies. Events were reshaping the world. Capitalism was well established in America and in many nations of Europe. Improved methods of transportation facilitated travel to distant lands. Japan became a more open society, and the import of Ukiyo-e prints, with their hard edges and respect for two-dimensionality and simplicity [FIGURE 1.9], had a major impact on progressive Western artists [FIGURE 1.10]. Some artists, inspired by the new eye of the camera, began to draw and paint what their eyes saw instead of what the academies said they were supposed to see. These artists, the impressionists, were the heretics of their age. One critic accused them of

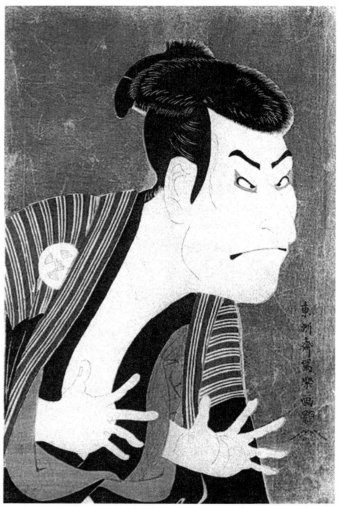

FIGURE 1.9
Toshusai Sharaku, 1794, polychrome woodcut print on paper. 15 × 9⅞".

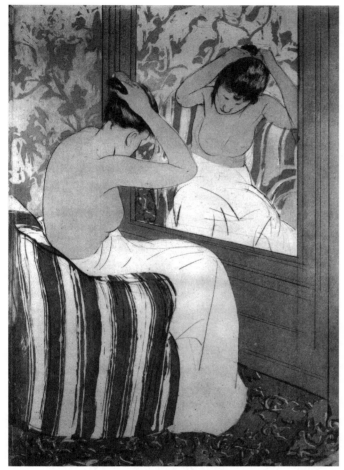

FIGURE 1.10
The Coiffure, Mary Cassatt, c. 1891, color print with drypoint and soft-ground, 14⅜ × 10½", Chester Dale Collection.
(Image courtesy of the Board of Trustees, National Gallery of Art, Washington, D.C.)

finding pebbles along the road to bedlam and mistaking them for jewels. Because of the impressionists' popularity since that time, their critical rejection has become a benchmark for questioning official taste.

Some artists, following Paul Gauguin's lead, continued absorbing influences from cultures other than their own, a trend that was to accelerate in the first decade of the twentieth century—another moment of scientific and intellectual upheaval. The art that had the most seminal and far-reaching impact on young artists of Europe was from Africa, especially African masks [FIGURE 1.11]. Before 1900, the words "primitive art" meant little more than non-Western art. Aboriginal work was of interest to the ethnologist but not the artist. This attitude of exclusion underwent a permanent change when a group of young Parisian artists found a power and innocence in primitive works that turned out to be the perfect antidote to the perceived European cultural decadence, and these works served as a model for their own attempts at direct expression. Picasso described his

FIGURE 1.11
African mask.
(© photos.com)

first visit to the African sculpture exhibition at the Ethnological Museum in Paris with enthusiastic praise. "The masks were not like any other piece of sculpture. Not at all. They were magic things ... the Negro pieces were *intercesseurs,* mediators." African sculpture provided the impetus for cubism, "the art that broke the looking glass," as a 1960 exhibition title by Douglas McAgy described it [FIGURE 1.12].

The early years of the twentieth century presented artists with new challenges from science. New mathematical theories undermined the tenets of Euclidean geometry, the basis of linear perspective. The invention of the X-ray added more doubt to the legitimacy of rendering surface appearances. Cezanne's inclusion of multiple viewpoints in a single painting provided a precedent, and therefore an authority, to the cubists' fracturing of space in a manner unknown before in the history of world art. It seems in hindsight that given this atmosphere of exploration that a totally non-objective art would automatically emerge. But it's well to remember that this dramatic twentieth-century discovery did not drop from the sky but was the result of the pain and struggle of individual artists facing up to the call of their time. Art had long since lost its great patronages of the past, and the artist began the irrevocable movement away from "this talent for hire"

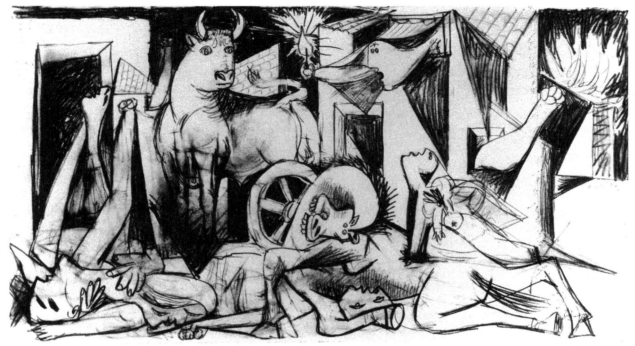

toward the role of a major voice in society's conscience [FIGURE 1.13].

NEW QUESTIONS

In a world where each of us has access to the same information, artists can no longer speak of this tradition or that tradition as being their special province. Old boundaries are blurred beyond recognition. Where does drawing end and other media begin? Does it matter? Are the old categories simply no longer viable? These are questions for each of us to consider and reconsider if we want to understand the perpetually changing art world.

Once we thought we knew what drawing meant. Anyone who went to school, drew. Drawing was considered a meditative discipline within everyone's reach, like math or reading. In the late years of the nineteenth century, public schools in Massachusetts were required by law to teach drawing. But in recent times, the diverse definitions of drawing have caused educators to doubt not only what the term means but why it has any benefit at all for the general student. Ironically, the computer, despite the untouched-by-human-hands quality of its products, may be moving us toward a reversal of the trend away from drawing, since more and more professional areas show a growing need for graphic literacy.

CHAPTER TWO
PROCESS OR PRODUCT?

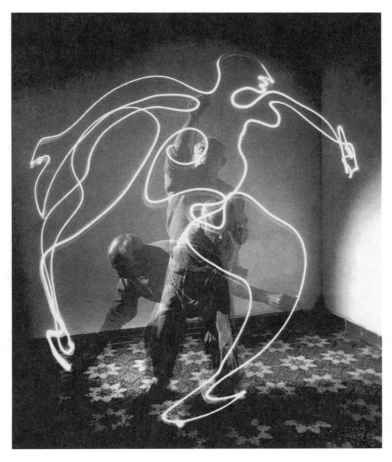

"Drawing is a verb." —RICHARD SERRA

"With all respect to Serra, for many artists today drawing is not a verb but a noun." —LAURA HOPTMAN

In ancient Egypt, artists often drew on *ostraka* (shards of limestone or pieces of broken pottery) that were bound for the junk heap, unworthy of preserving [FIGURE 2.1]. Such was the fate of drawing for two millennia—a handmaiden to painting and sculpture—until sixteenth-century Italy when Michelangelo began making gifts of his figure studies to special patrons and friends. A half-century later the groundbreaking Carracci Academy in Bologna decreed drawing to be the basis of art and, therefore, the foundation of all art training. This concept failed to convince the artists of Venice who continued to draw for themselves alone, some leaving few graphic works for future generations to study. Thus started the vacillation between drawing as product and drawing as process that continues to this day.

DRAWING AS A VERB

The simple relatively inexpensive materials of traditional drawing are well suited to spontaneous work. We associate drawing with the dreaming stage of art: for "processing" rather than polishing, although as a medium it has the capacity to do both. Emphasis on process allows a work to discover itself, to evolve, as it is being made rather than relying on

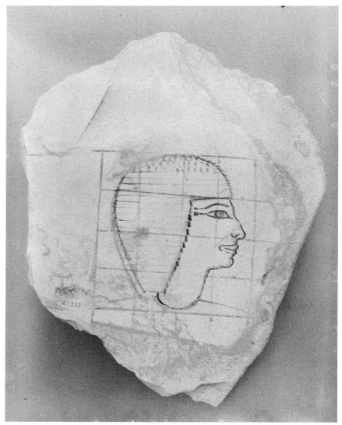

FIGURE 2.1
Ostracon of Senenmut, Egyptian, Thebes, Sheikh abd el-Qurna, New Kingdom, ca. 1473-1458 B.C., painted limestone, H. 8⅞ × 7¼. (The Metropolitan Museum of Art, Rogers Fund, 1936 [36.3.252]. Image © The Metropolitan Museum of Art)

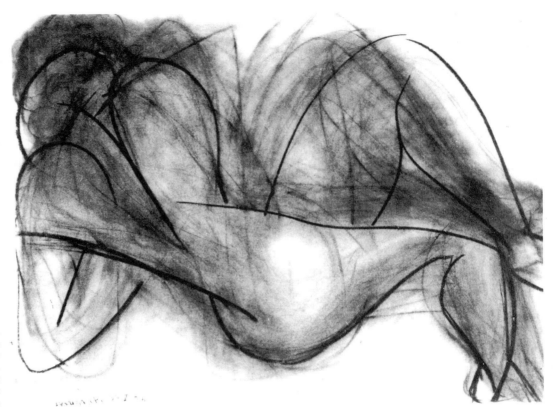

FIGURE 2.2
Reclining Nude Seen from the Back,
Henri Matisse, 1938, charcoal on
paper, 23⅝ × 31⅞".
(© 2007 Sucession H. Matisse, Paris
/ Artists Rights Society [ARS], New
York)

preconceived ideas. Henri Matisse's *Reclining Nude Seen from the Back* [FIGURE 2.2] allows us to see many of the earlier stages of the drawing, revealing some idea of its journey. Similarly, in Frances Hynes' mixed media work on paper [FIGURE 2.3], we intuit that its final stage arrived as a surprise as well as a synthesis of risks and discoveries that could not have been preconceived. The work that emphasizes process gives no thought to elegant execution, and much attention to the lively breathing quality of the surface resulting from materials used in a searching way. Above all else, processing presumes knowledge of spatial

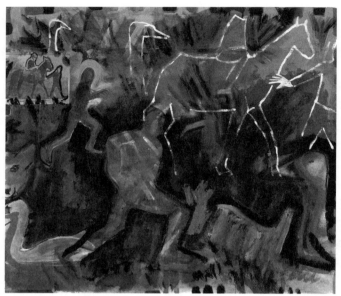

FIGURE 2.3
Holding Back the Horse, Frances Hynes, 1995, watercolor, gouache and collage on paper.
(Courtesy of the artist)

composition and a willingness to manipulate materials freely.

GESTURE DRAWING

Gesture drawing also puts heavy emphasis on the process, on the verbs. In the context of drawing, the word gesture makes a double reference: it can mean the spirit of a line or other formal force accomplished by the artist's moving material across a page, or it can refer to the pose of an object or live model. These two qualities merge in successful gesture drawing. Rembrandt's marvelously free ink drawings are supreme examples of putting emphasis on the verbs [FIGURE 2.4]. His mastery of visual shorthand comes as a surprise to anyone familiar only with his paintings. These freely rendered drawings are the parents of his paintings, even though the relation may not be obvious without a firsthand view of his lush impasto brushwork.

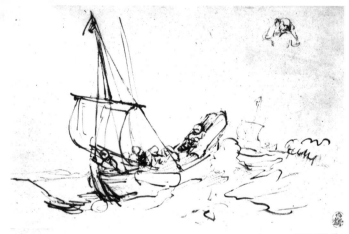

FIGURE 2.4
Christ in the Storm on the Sea of Galilee, Rembrandt Van Rijn, c. 1654–1655, pen and
bistre, 7¼ × 11¼".
(Kupferstich-Kabinett, Dresden Kupferstich-Kabinett, Dresden)

In the drawing shown here, *Christ in the Storm on the Sea of Galilee*, almost any detail, with the possible exception of the heads, would be abstract lines, totally non-descriptive, if viewed out of context. But in context, we feel what the artist felt: the churning power of the sea tossing a boat full of figures. So it's the *tossing*—not the description—that is the essence of the drawing. Gesture, here as always, implies both the movement of Rembrandt's hand as the pen scuttles across the page as well as the tossing of the boat.

Anyone who would capture the gesture of a subject *must* be able to empathize with the subject. My dictionary defines empathy as an understanding "so intimate that the feelings, thoughts and motives of one are readily comprehended by another." We see a mountain rise in the distance. We see branches of a tree sway in the wind. We see a tired man slump in his seat. The gesture in these events is the "rise," the "sway," the "slump"—in other words, the verbs that tell us what is happening. All things have gesture: a doorknob, a tree stump, a pile of shoes, a calligraphic mark, a kick. It is for the drawer to identify gesture and bring it into life in her work [FIGURE 2.5].

The absence of gesture is just as noticeable as its presence. Those portraits where the sitter just won't

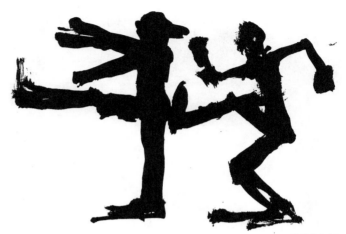

FIGURE 2.5
Study for the Kick, June Leaf, 1976, acrylic on paper, 7'2 by 9'2".
(Edward Thorp Gallery, NY)

stay down in the chair, the landscapes with clouds that seem to weigh a ton or stones that look as light as marshmallows; these are instances where the artist was not able to empathize with the subject.

EPHEMERA

For some drawing—especially visual note taking—any material on hand will work as well as expensive drawing paper. Picasso, the great experimentalist, even drew with a flashlight [FIGURE 2.6]! Adults tell stories of how, as children, they drew on scrap paper with

anything that was handy. Some professional artists draw on pages from books or phonebooks, old newspapers, magazines, walls, scraps of wood, plywood, old doors, etc., either because such material is available and economical, or for effect. Some of the finest Native American drawings are to be found in ledger books [FIGURE 2.7] provided by Indian Agents.

In our throw-away culture, we find paper bags, used envelopes, paper towels, napkins, butcher paper, wrapping paper, labels, flyers, posters, newspapers,

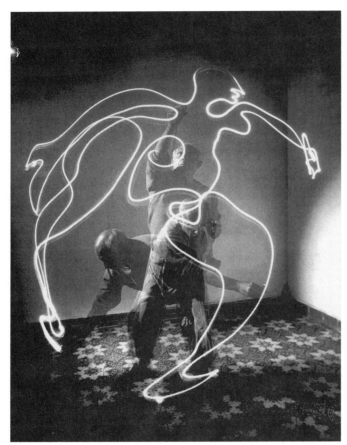

FIGURE 2.6
Picasso drawing with a flashlight.
(Gjon Mili / Time and Life Pictures / Getty Images)

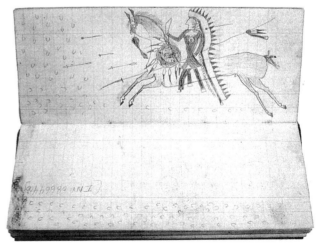

FIGURE 2.7
Indian ledger book drawing.
(Reprinted by permission of the National Anthropological Archives, Smithsonian Institution)

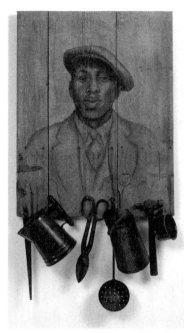

FIGURE 2.8
Wise Like That, Whitfield Lovell, 2000, charcoal on wood, found objects 45 × 23½ × 10¼ inches.
(The Metropolitan Museum of Art, New York)

cardboard boxes, and on and on, there for the taking on a daily basis—all recyclable as drawing surfaces. A positive feature of found material is that it lacks uniform size and surface, unlike the manufacturer's drawing pad that decides beforehand the size and shape of the artist's mind. For media, remember ballpoints, yellow pencils, flat carpenters' pencils, crayolas, marking pens, charcoal briquettes, sticks dipped in ink, catsup, tea, and coffee, and so on as far as the imagination will allow [FIGURE 2.8].

DRAWING AS A NOUN

Drawing's capacity for meticulous finish work makes it a medium in its own right; no longer just a helpmate to painting or sculpture. Creating a highly finished drawing can be a tedious project not compatible with every temperament, including my own [FIGURE 2.9]. A cynic might say that finished drawings are market driven. Although sometimes true, let's remember that some artists find fulfillment in every step of the

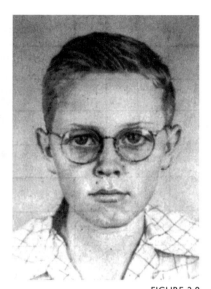

FIGURE 2.9
Unfinished self-portrait as a ten-year-old, Roger Winter, 1973, pencil on paper.

process—watching a work materialize millimeter by millimeter, maintaining the same level of craft throughout from beginning to end. To work with such patience and perseverance can produce drawings that are almost beyond belief, like magic.

The twentieth-century American painter/ photographer/graphic artist Charles Sheeler was a master of finished drawings. Always working from his own photographs, Sheeler's drawings have a flawless

and timeless quality about them despite the temporality of their subjects. In *Feline Felicity* [FIGURE 2.10], one of Sheeler's most famous drawings, he drew with very fine strokes of conte crayon. His obvious mastery of craft gives such a naturalness, a sense of inevitability, to the drawing that we may overlook its carefully considered spatial organization. The sleeping cat is placed against an architectonic space created by the lines of the room in play with the forms of the slat-backed Shaker chair. The cat's rhythmic patterns are continued in the shadows of

FIGURE 2.10
Feline Felicity, Charles Sheeler, 1934. Black crayon on paper; image: 35.8 × 33.5 cm (12⅛ × 13³⁄₁₆").
(Harvard University Art Museums, Fogg Art Museum, Louise E. Bettens Fund, 1934.182. Imaging Department © President and Fellows of Harvard College)

FIGURE 2.11
Departure, Brian Cobble.
(Courtesy of the artist)

limbs and foliage coming through a window from outside the picture plane. Values (light and dark) range from the open blacks of the shadows on the left through a myriad of middle values to a few small light areas where the paper appears to be blank. The drawing's complex system of diagonals adds to a dynamic space.

Another artist whose vision and uncanny patience produces drawings of exquisite detail is the New Mexico photorealist Brian Cobble [FIGURE 2.11]. Cobble, too, works from his own photographs, and his selection of subject is obviously a vital part of the process. He shies away from no complexity, giving each detail of the drawing the loving attention that it must

have. Each square inch is as objectively treated as the next, leaving no "hot spots." His drawing, rather than opinionating, simply reveals information, and it is this revelation that is the content of the work. Like the seventeenth-century Dutch painters, Cobble finds a poetry in the presentation of facts.

The often-heard cliché that the camera ended all need for naturalistic drawing and painting is not true, since it assumes that because a naturalistic work resembles a photograph, it is no more than a photograph. It disregards the artist's marks, the simplifications, the emphases. This assumption is even more far-fetched in reference to drawings done directly from life since such drawings are always more than mechanical duplication: the subject, and possibly the light, shift from moment to moment, hour to hour. A portrait from life, as in this drawing by Japanese artist, Hiromi Nomurajima [FIGURE 2.12], is a synthesis of shifting phenomena over a period of weeks, unlike the frozen immediacy of a photograph.

While there is a touch of the obsessive in Sheeler's and Cobble's works, they are expressionistic compared to some self-taught artists who take obsession to its essence, spending countless hours composing and rendering meticulous designs, geometric or otherwise

FIGURE 2.12
Jessie, Hiromi Nomurajima, 2006, charcoal and pastel on paper, 39 × 27½".
(Courtesy of the artist)

FIGURE 2.13
Untitled, Martin Thompson.
(Collection of Selig and Angela Sacks,
New York)

[FIGURE 2.13], with modular units so small they give the sense of being too much to ever grasp, like the multiplicity of cells in a human body. Yet a larger pattern is always present, and it brings clarity to the overall design. One never gets the impression of impatience or pain in the execution of such drawings. On the contrary, observing them brings the viewer a sense of satisfaction, of fulfillment.

A FULL SENTENCE

Many artists—all artists to differing degrees—produce drawings of a systemic soundness through synthesis of both verbs and nouns with a few adjectives thrown into the mix. Kathe Kollwitz's *Self-Portrait* [FIGURE 2.14] is a fine example of a drawing that balances process and product. The bold gestural strokes that describe the arm and torso somehow manage to integrate with the carefully rendered hand and face. The rendering of the back of the head starts to merge with the page space, while the shoulder's contour line provides a boundary for the arm and torso's bold free marks. Placement, directional flow, emphasis, and contrast all work together to energize the space of the page. In twentieth-century terms, Kollwitz was a complete artist.

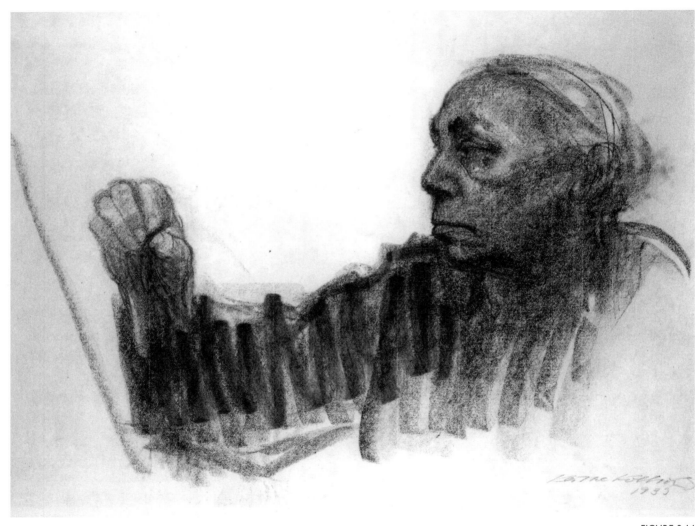

FIGURE 2.14
Self-Portrait, Kathe Kollwitz, 1933, charcoal on paper, 18¾ × 25".
(© 2007 Artists Rights Society [ARS], New York / VG Bild-Kunst, Bonn)

CHAPTER THREE
CUTTING

*"A line is a track made by the moving point; that is, its product. It is created by movement—
specifically through the destruction of the intense self-contained repose of the point. Here,
the leap out of the static into the dynamic occurs."* —WASSILY KANDINSKY

positive and negative! The line that divides shape from shape leaves both areas with equal strength. The Japanese word for the Western artists' negative space is "ma," an essential design element pregnant with energy.

SCISSORS

The ultimate dividing line is the line that a scissor cuts. This unequivocal, time-honored approach to drawing was once a parlor game called "silhouette cutting" [FIGURE 3.2]. In some cultures scissor cutting is an intricate and decorative art form. Perhaps the finest cut paper work ever done is in a sixty-seven-minute animated film, *The Adventures of Prince Achmed*, first shown in 1926. The animator,

Line can refer to many, many different properties. Lines are hatched and cross-hatched to create values. My students referred to lines that had facile accents and width variations as "art lines," putting superficiality in its place. Lines can be meandering, suggestive, or incisive [FIGURE 3.1]. Or a line can simply divide one area from another. By definition, such a line needs no intrinsic qualities—no style. It simply separates one shape from another shape. How misleading it is to refer to these shapes as

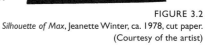

FIGURE 3.3
Still from animated film *Prince Achmed*,
Lotte Reininger, 1926, cut paper.
(BFI Stills)

German artist Lotte Reiniger, cut each exquisite frame of this film separately [FIGURE 3.3].

The American artist Kara Walker adopted silhouette cutting to create her monumentally sized, intensely personal body of work that retells the story of the African Americans' relationship to white slave owners and to each other in the antebellum American South. Walker's line is cut with such amazing grace that we may miss at first glance her edgy narratives [FIGURE 3.4].

For Auguste Rodin, cutting paper was an extension of his involvement with the tools of sculpture. He surely

knew the collages of Picasso and Braque, but Rodin's involvement with cutting came from a different vantage point than that of the cubist collagists whose purpose was to fracture time and space in a dynamic way. Rodin cut as a means to enhance some of his fleeting pencil and wash drawings by separating an image from the boundaries of its original context and then physically and permanently parking it in a new relationship to the periphery of the page [FIGURE 3.5]; hence, a way to design with simple forms rather than the explosive treatment of deep space by the cubists.

In contrast, cubist collagists thoroughly immersed their work in disjunction. This, plus the psychological impact of placing a fragment of string, printed matter, and so on, where it obviously didn't belong in any logical

FIGURE 3.4
Cut, Kara Walker, 1998, cut paper and adhesive on wall. 88 × 54".
(Image courtesy of Sikkema Jenkins & Co.)

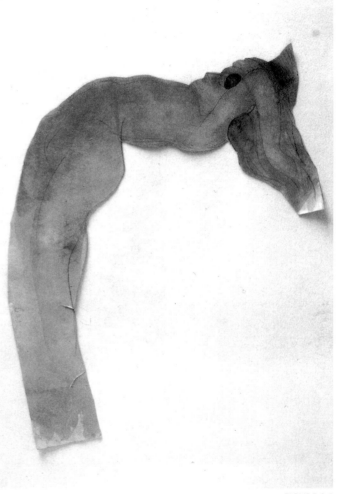

FIGURE 3.5
Femme nue de profil et cambree, Auguste Rodin, cut paper.
(© 2007 Artists Rights Society [ARS], New York, ADAGP, Paris, and Musee Rodin)

FIGURE 3.6
Glass and Bottle of Suze, Pablo Picasso.
(© 2007 Estate of Pablo Picasso / Artists Rights Society [ARS], New York)

sense, destroyed the linear nature of subject and space, ultimately freeing the formal elements from the pictorial [FIGURE 3.6]. The German artist Kurt Schwitters took collage past the flat state into full-blown three dimensions.

The surrealist artist Max Ernst concentrated on another level of collage: its capacity to juxtapose images that had no rational relationship. Ernst's collages altered existing visual narratives with minimal changes [FIGURE 3.7]. He was master of combining two or more incompatible realities on one surface, thus causing a spark of poetry to "leap across the gap as these two realities are brought together."

So many artists have worked with collage on so many levels that we may be tempted to forget that as a medium, it is still less than 100 years old. It is nevertheless old enough that any shock value it may have had disappeared generations ago. Already, digital collagists are falling into yawn-inducing mannerisms. Anyone wishing to work with collage has the daunting task of bringing an original voice to the medium. Otherwise the work will appear threadbare, stale. Someone whose collages *have* found a niche in the story of art is the montagist/mail artist Ray Johnson. Without fanfare, Johnson's small, intimate, intensely

FIGURE 3.7
Une Semaine DeBonte, Max Ernst, 1934.
(© Artists Rights Society [ARS], New York / ADAGP, Paris)

FIGURE 3.8
Untitled (Gertrude Stein with Judy Garland's Kitchen), Ray Johnson, 1975, collage.
(The Estate of Ray Johnson, Richard L. Feigen & Co., New York)

personal, jaded, humorous works—often in the form of letters mailed to friends and strangers—continue to excite audiences more than a decade after his death [FIGURE 3.8]. Johnson, referring to his work, said, "It's my resume, it's my biography, it's my history, it's my life."

The most powerful synthesis of collage and painting in twentieth-century art is found in the works of the African American artist Romare Bearden [FIGURE 3.9]. His passionate dream of merging cultures, energized by comprehensive knowledge of world art and literature, was further intensified through identification with the art of Africa, his catalyst. Bearden's work has an emotional content and an orchestration of disjunctive space that surpasses most of the work of his time.

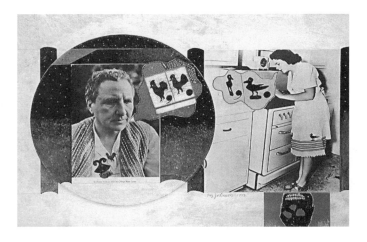

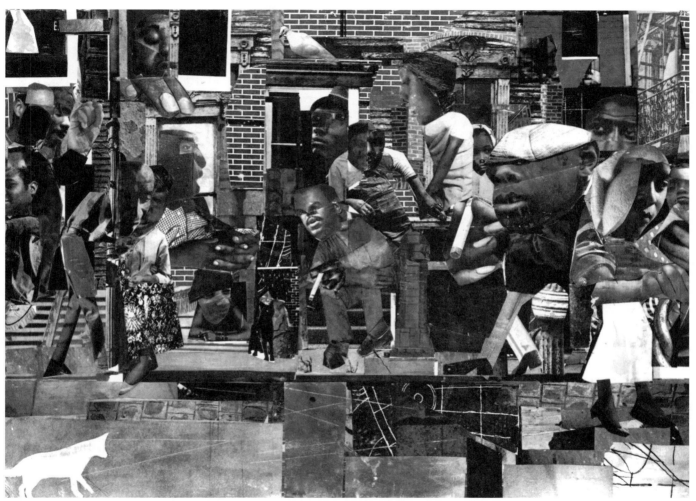

The Dove, Romare Bearden, 1964, cut-and-pasted paper, gouache, pencil, and colored pencil on cardboard, 13⅜ × 18¾". Collection of the Museum of Modern Art, New York. (© Romare Bearden Foundation / Licensed by VAGA, New York, NY)

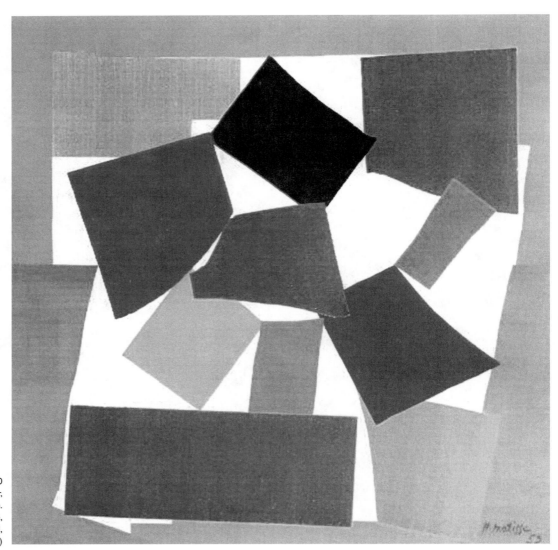

FIGURE 3.10
The Snail, Henri Matisse, cut paper,
9'4¾" × 9'5". The Tate, London.
(© 2007 Succession H. Matisse,
Paris / Artists Rights Society [ARS],
New York)

Bearden had an uncanny gift for evoking the places of our collective memory. He derived his repertoire of subjects from New York's Harlem neighborhoods and the North Carolina rural community of his youth.

Bearden once told a friend that the French master Henri Matisse "got as close as one can get to heaven" with a pair of scissors. Matisse, always a linear artist, began cutting paper later in life after a prolonged illness confined him to a wheelchair. Cut paper for Matisse meant combining line with color [FIGURE 3.10]. "Cutting straight into color," he said, "reminds me of what a sculptor does to his stone." Some of the cut paper works were carried out on a massive scale, and despite his help from assistants, it is none the less inspiring to see photographs of the wheelchair-confined Matisse working on such a heroic scale. One of his last works, *The Snail*, is 9' 4 ¾" × 9' 5".

Matisse's cut paper works would not have happened without the spadework of the early collage artists. Nothing enters the world full-grown. Each of us is part of a continuum. In turn, Matisse's work has encouraged an untold number of artists to explore this hybrid medium for their own purposes. A notable example is Japan's graphic designer and children's bookmaker, Katsumi Komagata. Katsumi has turned paper cutting

FIGURE 3.11
Pages from *Sound Carried by the Wind*, Katsumi Komagata, 2005, children's book. (Copyright by Katsumi Komagata. Published in 2004. Reprint in 2005, 2007. Publisher: ONE STROKE CO., Ltd.)

into a method of illustration that can be produced in multiples, bound and then distributed as books. His illustration is elegant and reductive [FIGURE 3.11]. His books are not without words, but the words are minimal and, therefore, in perfect harmony with the simplicity of the visual matter.

ASSEMBLAGE

Assemblage is a relative of collage, although its method of cutting and joining wood, metal, etc., is

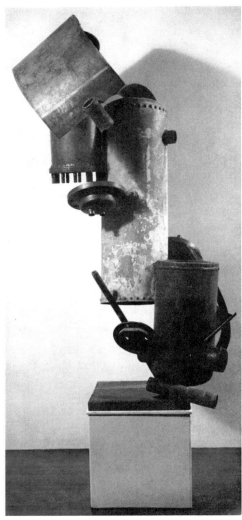

FIGURE 3.12
Untitled, Richard Stankiewicz, 1961, welded scrap steel parts, 67" high.
(Courtesy Zabriskie Gallery and the estate of the artist)

antithetical to cutting and pasting paper. Assemblage was obviously not the first approach that freed sculpture's formal elements from the burden of illusion, but like collage, it liberated objects from their function. Assemblage typically made use of "junk" from a throwaway culture that the machine age created. Junkyards became a rich resource of raw materials. Although Picasso and others (many outsider artists among them) worked with scrap metal prior to that group specifically called asseblagists, it was artists like Richard Stankiewicz who brought single minded devotion and stylistic elegance to the medium [FIGURE 3.12]. The American painter and critic Fairfield Porter wrote that Stankiewicz's junk sculpture was a "creation of life out of death, the new life being of a quite different nature than the old one that was decaying on the junk pile, on the sidewalk, in the used car lot. . . . His respect for the material is not a machinist's respect, but the respect of someone who can take a machine or leave it."

Alexander Calder's marvelous gift for assembling found material is best seen in his miniature circus—an ongoing project that lasted throughout his adult life. Calder took bits of wood, string, wire, cork, tin, and so forth, and, like an alchemist, turned them into a high achievement in twentieth-century art. Although his mobiles are his most widely popular works, Calder's

oeuvre is unusually extensive. In addition to an enormous output of drawing, painting, sculpture, and book production, he was also an inventive toymaker. "They call me a playboy, you know," Calder said. "I want to make things that are fun to look at, that have no propaganda value whatever."

INSTALLATIONS

The breadth of usage of the word "installation," with its categories and subcategories, calls for a narrow definition for the current purpose that has nothing to do with the plumbing in a new apartment building. Installation, at present, means the placement of sometimes found and almost always ready-made objects arranged in a site—sometimes specific—as a medium for exploring space and/or communicating a conceptual, poetic idea. It is easy to see that installations are progenies of collage. But how do they relate to drawings? Many artists and art institutions now see drawing in its broadest possible light. They con-clude, rightfully, that drawing was not created in heaven but is something that is constantly evolving, something that we

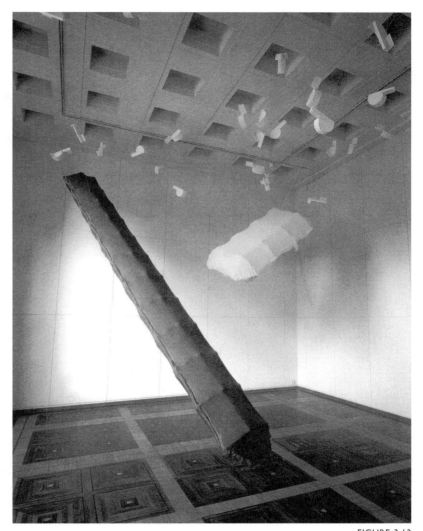

FIGURE 3.13

Momento Five, gray and yellow, Richard Tuttle, 2002, wood, fabric, cardboard, latex, monofilament, eyehooks. (Courtesy of the artist).

don't yet fully understand. The artist Richard Tuttle sees all his work as grounded in drawing, despite his proclivity for working in three dimensions, not in monolithic sculptural form, but more in terms of articulating space with scraps of wood, wire, nails, bits of cloth, string, pieces of plastic, pencil lines—whatever his eye finds usable at a given time [FIGURE 3.13]. I personally come away from Tuttle's work with a heightened sensitivity to materials—all materials. What he does, whether one wishes to call it drawing, sculpture, or installation, serves as a needed reminder that we who draw or who teach drawing are not simply keepers of a defunct faith but are proponents of an ever-expanding medium.

CHAPTER FOUR
DRAWING AND WRITING

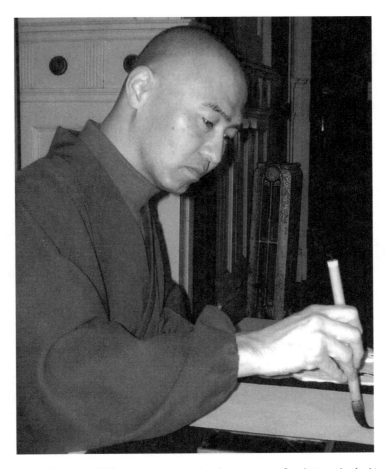

"Looking at the elegance of a page of Khmer script, at the handsome square Sanskrit, or the Arabic, at stones carved with the mysterious runes of the Anglo-Saxons, at early Greek tablets, the cuneiform stelae of the Sumerians.... Small wonder that so many people have attributed the origins of the alphabets to their gods!" —BEN SHAHN

Always, drawing came before writing. Pictographs preceded cuneiform writing, calligraphic characters, hieroglyphs, the scripts of ancient Mexico, and all other known forms of early alphabets. Drawing and writing evolved on separate but parallel tracks, the former becoming the medium of Rembrandt, the latter of Shakespeare. Only in isolated instances does drawing remain intimately linked with writing.

EARLY WRITING

The earliest known writing, from Mesopotamia, dates back 5,000 years. Almost as old are Egypt's pictorial hieroglyphs and Pakistan's ceramic seals. China's earliest writing is 3,500 years old. The earliest known writing in the Western hemisphere is from the Olmec culture of Mexico [FIGURE 4.1]; however, since this discovery is only a few years old, it's safe to think that a new archaeological find could determine otherwise.

EGYPTIAN HIEROGLYPHICS

The Egyptian alphabet wasn't deciphered until the early nineteenth century! A delay may have been caused by the confusing fact that some of the glyphs had a sound value while others were purely pictorial. The Egyptian writing system started with only picture

FIGURE 4.1
Facsimile of Olmec hieroglyphics from the Cascajal block, Vera Cruz, Mexico.
(Courtesy of the author)

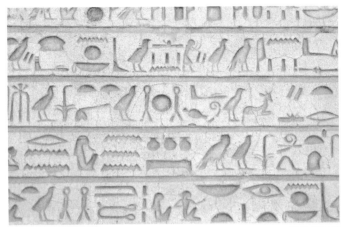

FIGURE 4.2
Egyptian hieroglyphics.
(© Corbis)

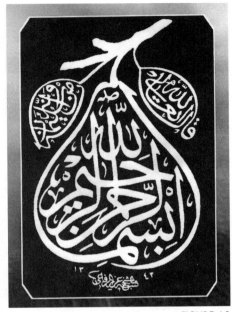

FIGURE 4.3
Arabic calligraphy of the "Basmala" phrase in the form of
a pear.

signs. Each sign represented what the picture stood for: a picture of a bull meant "bull," and so on. Pictorial hieroglyphs followed the same representational conventions used in Egyptian painting, weaving the most characteristic aspects of a subject into the image [FIGURE 4.2]. The phonetic alphabet moves back and forth between pictures (an eagle represents the sound "ah") and geometric symbols.

ARABIC

Despite the world's greater familiarity with the geometric patterning of Islamic tile work, Islam considers calligraphy to be the highest of the arts.

Because Arabic is the language of Islam, the calligraphic scripts that have evolved over the years are Arabic. The flowing script is sometimes combined with geometric tile designs for an especially rich visual/verbal mix [FIGURE 4.3].

CHINESE CALLIGRAPHY

While the Egyptians combined the phonetic *and* the pictorial, Chinese calligraphy is pictorial only [FIGURE

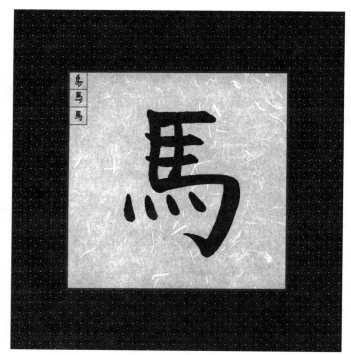

FIGURE 4.4
Evolution of Chinese calligraphic character for "horse."

4.4]. In legend, the Chinese characters came from drawings made by Tsangh-hseih, a four-eyed man who was fascinated by animal tracks, especially those of birds. Certainly more likely, the characters derived from pictographs engraved on pieces of bone dating from one to two millennia B.C. During the early centuries of Chinese writing, calligraphers drew with their beloved brush and ink on surfaces made of cloth. In about 100 A.D., a man named Ts'ai Lun mixed tree bark and bamboo fiber with water, pounded it into a pulp, and then poured the pulp onto coarse cloth and let the water drain and the pulp dry. The finished product was a lightweight easy to produce writing surface called "paper," named for the Egyptian plant, papyrus, the pulp of which had been in use as a writing and painting surface since the third millennium B.C.

China's age-old love affair with brush and ink doesn't stop with

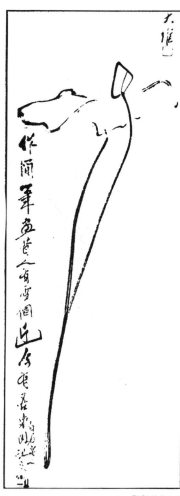

FIGURE 4.5
Prose Poem on Fishing (section of hand scroll), Chu Yung Ming, 1507, ink on gold-flecked paper, 12⅞" × 26' 9¼" (size of total scroll).

calligraphy but continues on into painting, especially landscape painting. Over many centuries, schematic brush marks were developed to guide the representation of trees, bamboo, birds, insects, the human figure, mountains, and practically everything else in the natural world. Calligraphy and painting are China's most significant fine arts. Each requires the gargantuan task of combining mastery of brush and ink with *ch'i*, the spirit of life [FIGURE 4.5, FIGURE 4.6].

In the seventh century A.D., Japan adopted Chinese calligraphy and developed a phonetic script to

FIGURE 4.7
Japanese calligraphy, Akemi Ishida, 2007, ink on paper, 13 × 9".
(Courtesy of Akemi Ishida)

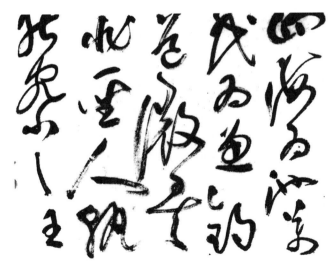

FIGURE 4.6
Chinese brush painting.

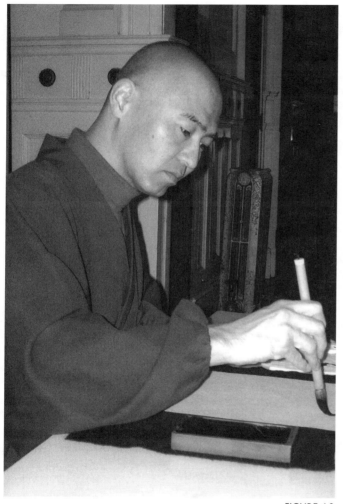

FIGURE 4.8
Rev. T. Kenjitsu Nakagaki demonstrating calligraphy.
(Photo by the author)

accompany China's picture-derived characters. Calligraphy, along with flower arranging, martial arts, and the tea ceremony remain Japan's highest arts [FIGURE 4.7]. As in China, the calligraphic characters are considered more than mere handwriting; rather, like all the visual arts, they are based on balance, placement, and the use of materials in a knowledgeable way [FIGURE 4.8]. The characters can be "read" on a formal as well as literal level: one can appreciate the beauty of their shapes, their flow, without being literate in Chinese or Japanese. Calligraphy, as practiced to this day, represents not only an intimate bond between drawing and painting, but also between image and sound, between form and content.

In recent decades, Chinese and Japanese artists have used the calligraphic characters as a starting point for wildly expressive black and white works [FIGURE 4.9] that have a link to the abstract expressionist tradition. Ironically the abstract expressionists, or action painters, found inspiration in Eastern calligraphy!

ILLUMINATED BOOKS

Before the printing press, books were produced one at a time—and produced gloriously. The Middle Ages in Europe saw the end of writing on stone, wood, and

metal, and the beginning of the use of rag-paper and quill pens. These new materials no doubt facilitated the writing and decorating of illuminated pages, adorned as they were with complex ornamental flourishes combined with figures, flora, fauna, and sometimes monstrous beasts, filling in spaces around and within the letters [FIGURE 4.10]. Burnished gold leaf "illuminates" these luxuriant pages, often further enhanced with patterns of red and blue. The books' subjects range from Psalters and sacred scriptures to bestiaries.

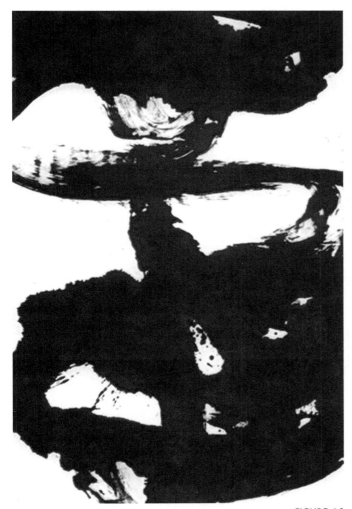

FIGURE 4.9
Confrontation of Yin and Yang, Wang Dongling (b. 1945), 2005. Ink on paper. 85 × 57".
(Courtesy of The Estrella Collection, New York, USA)

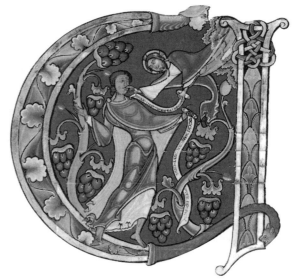

FIGURE 4.10
Illuminated letter.
(Reprinted by permission of the Winchester Cathedral)

But in this visual paradise exists a problem for modern minds. The illuminated books were for the privileged few. We take for granted that the written word is in everyone's reach via the library, the bookstore, or the Internet.

CONTEMPORARY HAND LETTERING

We may be accustomed to seeing well-drawn calligraphy only on invitations and greeting cards, but if we dig a little deeper we find a booming sub-culture of

FIGURE 4.12
Sign from Oaxaca, Mexico.
(Photo by Jeanette Winter)

calligraphers that requires special tools, explicit knowledge of form, and a respect for originality of style [FIGURE 4.11]. In contrast to the elegance of contemporary calligraphy, we also can find vernacular lettering that may be lacking in grace but rich in soul [FIGURE 4.12].

In recent decades, words and lettering style have found their way into traditional visual media—sometimes as a personal obsession [FIGURE 4.13] and at other times following a popular genre [FIGURE 4.14].

MODERN PICTOGRAPHY

When I was a child growing up in Texas, my family and I lived a few yards from the Missouri-Kansas-Texas railroad line that ran through my hometown. During these tough economic times, the 1930s and 1940s,

IF IT HAD NOT BEEN FOR THESE THING, I MIGHT HAVE LIVE OUT MY LIFE TALK-ING AT STREET CORNERS TO SCORN-ING MEN. I MIGHT HAVE DIE, UN-MARKED, UNKNOWN A FAILURE. NOW WE ARE NOT A FAILURE. THIS IS OUR CAREER AND OUR TRIUMPH. NEVER IN OUR FULL LIFE COULD WE HOPE TO DO SUCH WORK FOR TOLERANCE, FOR JOOSTICE, FOR MAN'S ONDERSTANDING OF MAN AS NOW WE DO BY ACCIDENT. OUR WORDS-OUR LIVES-OUR PAINS NOTHING! THE TAKING OF OUR LIVES-LIVES OF A GOOD SHOEMAKER AND A POOR FISH PEDDLER-ALL! THAT LAST MOMENT BELONGS TO US- THAT AGONY IS OUR TRIUMPH.

FIGURE 4.13
Immortal Words, Ben Shahn, 1958, serigraph in black, 15½ × 20⅜".
(© Estate of Ben Shahn / Licensed by VAGA, New York, NY)

FIGURE 4.14
Graffiti, Roger Winter, 2000, oil on museum board, 8 × 16".
(Courtesy of the author)

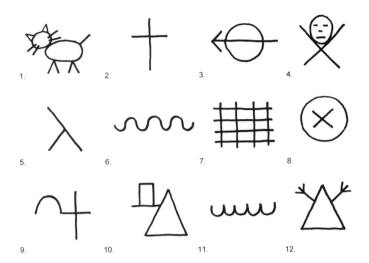

1. kind hearted lady 2. talk religion, get food 3. don't go this way 4. doctor
5. keep away 6. poor man 7. jail 8. good for a handout 9. halt 10. rich man
11. dog 12. man with a gun

FIGURE 4.15
Facsimile of hobo pictography.
(Courtesy of Jeanette Winter)

unemployed men who had no particular place to be, often rode freight trains. Our house was one of the first that the trains passed as they emerged from wooded land, and these homeless men—called "hoboes"—sometimes hopped off the trains and asked us for food in exchange for doing chores. The hoboes had their own pictorial language, and I was aware that they sometimes drew small pictures on mailbox posts in our area to let other men know what kind of treatment to expect from a given household. Their signs could warn about vicious dogs, or give clues about the level of generosity to expect, or signal a fellow traveler that an officer of the law lived in a particular house. This was my first experience with a form of communication that had no phonetic alphabet [FIGURE 4.15].

In this time, international signs have become a universal pictographic language [FIGURE 4.16]. These ubiquitous picture-signs are generally helpful in giving simple information, although their meanings can sometimes be unclear, like the hotel information sign that shows a man in bed with a

FIGURE 4.16
International sign.

huge question mark over his head. But in most cases, each of us understands intended meanings even though we express these meanings with totally different spoken sounds depending on our native language. International signing is a rescue net in the tower of Babel the contemporary world has become.

It is, indeed, likely that pictography will never be able to express the nuances we have come to demand of language. Nevertheless, international signs remind us that writing and drawing can still be bonded as they were in ancient times. They also serve as a nudge not to get too settled because writing *and* drawing are in a perpetual state of change.

CHAPTER FIVE
GEOMETRY

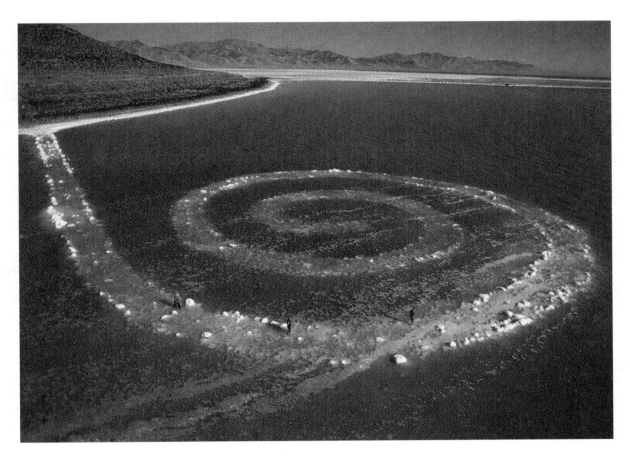

"What is God? He is length, width, height, and depth." —ST. BERNARD OF CLAIRVAUX

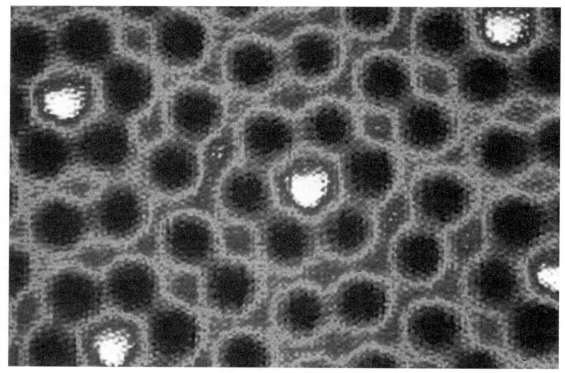

FIGURE 5.1
Silicon surface atoms enlarged 20 million times, 1981, IBM Corporate Archives. (Courtesy of IBM Corporate Archives)

The prevalent use of geometric design throughout human history suggests that we—like the workers in a bee colony—have a biological need to divide space with lines and angles: sub-mental emanations from an unknown force. Ancient cultures used geometry as a way to explain the universe, and modern science can show by way of refractive photography that matter, enlarged millions of times, has a geometric basis [FIGURE 5.1]. Geometry is part of our daily lives in highly visible ways. We arrange our cities on grids, and we continue the grids in floor plans and on the sides of buildings. We live life in environments that could be extensions of our own cellular makeup.

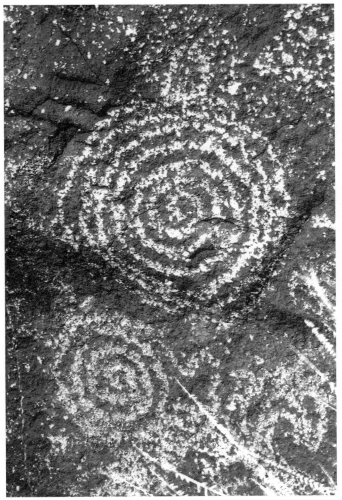

FIGURE 5.2
Petroglyph, New Mexico.
(Photo by the author)

FIGURE 5.3
Untitled, Eva Hesse, 1966, acrylic paint and cord over papier-mache on wood,
7½ × 7½ × 4".
(The LeWitt Collection, Connecticut. © The Estate of Eva Hesse. Hauser & Wirth
Zurich London)

Geometry in art occurs in all times and in all places. Prehistoric art is rich with drawings of simple geometric forms [FIGURE 5.2]. The spiral is common in all cultures, including our own [FIGURE 5.3, FIGURE 5.4]. The Hindu/Buddhist mandala form (pronounced manDAHla), a circle, often divided into four parts

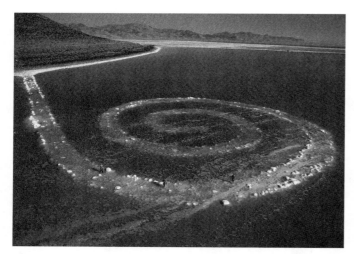

FIGURE 5.4
Spiral Jetty, Robert Smithson, Great Salt Lake, Utah.
(Art © Estate of Robert Smithson / Licensed by VAGA, New York, NY)

FIGURE 5.5
Mandala.
(Copyright © by Cindy Oriente. All Rights Reserved)

before elaboration, serves as an object that assists meditation [FIGURE 5.5]. Despite its origins in the east, mandala designs can be found in the domes of cathedrals throughout medieval Europe.

THE GOLDEN SECTION

Though classical Greek art is associated with hyper-naturalistic figurative sculpture, the figures are formed according to an explicit set of ideals concerning human proportions. Some writers find in Hellenistic art wide use of the golden section, also called the golden ratio. While this may be the case, it's well to remember that

sightings of the golden section are as common as celebrity sightings, and often as credible.

The golden section refers to a line divided into two segments that have the ratio: a + b is to a as a is to b [DIAGRAM 1]. To extend the golden section into a golden rectangle follow the instructions here [DIAGRAM 2]. This ratio was known and used in cultures much

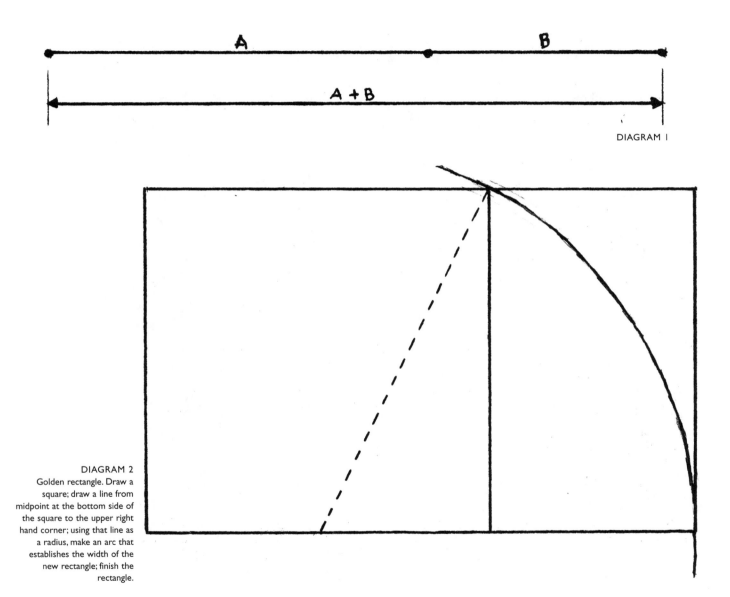

A

B

A + B

DIAGRAM 1

DIAGRAM 2
Golden rectangle. Draw a
square; draw a line from
midpoint at the bottom side of
the square to the upper right
hand corner; using that line as
a radius, make an arc that
establishes the width of the
new rectangle; finish the
rectangle.

earlier than the Greeks, but it is associated with ancient Greece because the geometer Euclid wrote the first definition of it, referring to the golden ratio as the "extreme and mean ratio." Furthermore, the Parthenon and its statues appear to be constructed according to a golden rectangle. From the Renaissance forward, artists, architects, and designers, especially book designers, have experimented with the proportions of the golden section, and it constituted the core of twentieth-century architect Le Corbusier's philosophy of proportion. Explaining his philosophy in his book *Modular*, Le Corbusier finds the ratio resounding "in man by an organic inevitability, the same fine inevitability which causes the tracing out of the golden section by children, old men, savages and the learned."

GEOMETRY IN ABORIGINAL ART

Figurative art in aboriginal cultures relies exclusively on geometric stylizations, and we have cause to be happy that these artists relied on intuition rather than iron-binding rules.

Always remember that the geometrizing of figurative art never represents an inability to do otherwise. Instead it accommodates cultural values that see naturalism as imitating the mere skin of reality and is

therefore unworthy of representing deities or others of the spiritual realm—the subjects most often required of artists [FIGURE 5.6]. Here I use the word "artists" for convenience, knowing the concepts of "art" and "artists" to be foreign to aboriginal cultures. The objects we refer to as art, that is, "primitive art," serve a spiritual purpose not directly related to aesthetics.

FIGURE 5.6
Door jamb figure, wood, New Caledonia, 70" high.
(Musee Nationale des Arts Africans et Oceaniens)

The geometrized female figure has been an art subject for at least 25,000 years. Why this is so is still, and may always be, guesswork. A feasible explanation is that the oldest of the female figures symbolized the goddesses in matriarchal cultures.

Archaeologists have found geometric figures, female and male, of somewhat similar style in areas worldwide

as geographically removed as Mexico and Moravia. The discoverers often thought these finds were crude, even ugly. Such was the case with the figures found in the Cycladic Islands [FIGURE 5.7] until early-twentieth-century European artists pointed out the beauty of these haunting simple sculptures. Their influence on twentieth-century sculptors, especially Constantin Brancusi, is well known [FIGURE 5.8].

The geometric masks of sub-Saharan Africa, like the

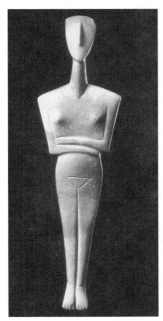

great figurative art of the Americas, also were considered of ethnological interest only until their already described impact on the seminal art of the twentieth century. We now view these "primitive" works as an important part of the great story of art, and possibly more relevant to the art of our time than that of the more civilized European and Asian traditions.

ISLAMIC ART

In Islam, geometry and art became fused by the religious commandment that forbade the representation of images. Islamic artists were free, one

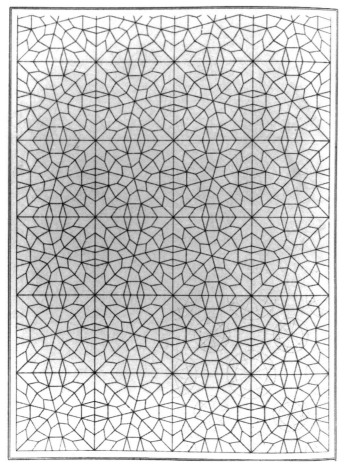

FIGURE 5.9
Islamic pattern.

might say, to search for the invisible laws that determine the kind of space we live in with its unbreakable properties [FIGURE 5.9].

GEOMETRY AND THE TWENTIETH CENTURY

So many of the "isms" of twentieth-century art were directly linked to geometry. Suprematism, de Stijl, constructivism, neoconstructivism, Bauhaus design, minimalism, primary sculpture, serial art, op art, conceptualism, color field: all of these relied either exclusively or most of the time on basic geometric forms. Sometimes geometric art evolved from nature, as Van Doesburg's *Cow* [FIGURE 5.10], but more often a pure art derived from a pure geometry. Geometry was the twentieth-century giant killer that not only slew illusionism and other referential styles, but also expressionism, sfumato, the facile edge—all the energy-sapping art baggage that earlier generations had piled on the backs of a new world. As minimalist Donald Judd said, "The first fight almost every artist has is to get clear of old European art." Geometry provided a lifeline for getting clear.

LINEAR PERSPECTIVE

The rendering of space is often based on one or another geometric theory. The best known theory, at

least in the West, is called linear perspective. Based on many years of watching people learn to draw, I think that most students would, through observation, learn to make adequate illusions of space without any knowledge of rules, just as the Romans did. But to be ignorant of rules seems almost as fraught with pitfalls as to be a slave to them.

If an artist has interest in linear perspective it's because it enables her to create an illusion of space on a two-dimensional plane, while a scientist is more likely to be interested in perspective to explain how the eye sees. For the artist, perspective leaves much to be desired. For instance linear perspective is based entirely on monocular vision, while most artists see the world with two eyes. But despite its shortcomings (other problems are discussed later in this chapter), linear perspective remains a basic teaching method for those who emphasize spatial illusion.

In the nomenclature of perspective, the picture plane is an imaginary rectangular plane between the

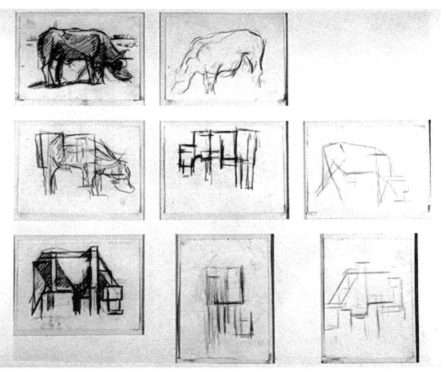

FIGURE 5.10
Cow, Theo van Doesburg.
(© 2007 Artists Rights Society [ARS], New York / Beeldrecht, Amsterdam)

observer and the observed. It corresponds to the surface plane of a drawing. The horizon line is a line drawn across the surface plane, and it always corresponds to the eye level of the observer. The underlying principle of linear perspective, and this is based on Euclidean geometric theory, is that parallel

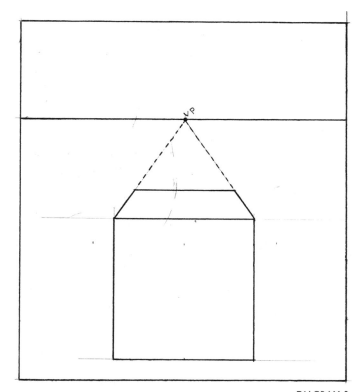

DIAGRAM 3

viewer's eyes. The frontal plane in the cube that is parallel to the viewer stays unchanged. But the lines in the top of the plane, like the lines of a highway, appear to be getting closer together as they move away in space. If the lines of the top plane were extended, they, too, would appear to converge on the horizon line [DIAGRAM 3].

If the cube is placed at an angle, or obliquely, in relation to the viewer, we can see that we now have two sets of converging parallels. Therefore, we need two vanishing points to make a drawing of the cube. None of the planes in two-point perspective are parallel to the observer. All visible planes appear to converge, and they all use the same two vanishing points [DIAGRAM 4].

Sometimes a third vanishing point is needed. If a form, such as a skyscraper, goes high above our eye level, we can use a third vanishing point to show the convergence of verticals [DIAGRAM 5].

lines *seem* to converge as they move away from the observer. A classic example is one's view of a highway whose lines appear to join at the horizon. The point where they converge is called a vanishing point. In one-point perspective, a cube projected into space is parallel to and therefore directly in front of the

Linear perspective may be useful as an aid to seeing and to understanding the way we see. It is of greatest use when drawing architectural forms, and of less use when drawing figures, landscapes, and other subtle organic forms. Its rules, if followed explicitly, can be somewhat ridiculous. Imagine, for instance, being on the twenty-fifth

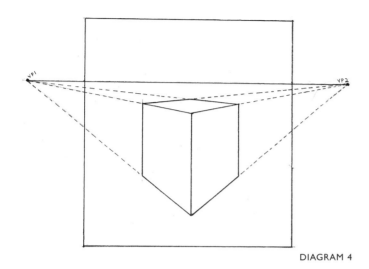

DIAGRAM 4

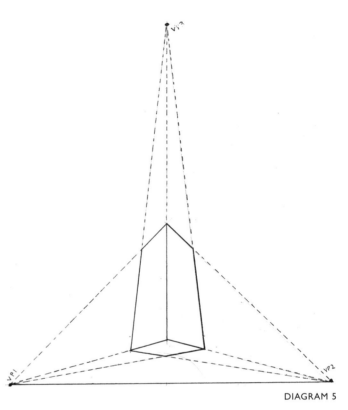

DIAGRAM 5

floor of a building looking out a window at a building fifty stories high. Vertical vanishing points would suggest that you see the building as a diamond shape, thus defying common sense. Even more troubling for an artist would be the need to set up diagrams with various points and lines before starting each drawing. Linear perspective, for most contemporary realist artists, is used only as a general guide—a spatial checklist.

ISOMETRIC DRAWING

In isometric drawing, parallel lines remain parallel [DIAGRAM 6]. This approach is especially useful in industrial design or any other area where accuracy in measurement is more important than spatial illusion. To the traditional Far Eastern artist, isometric drawing represents an obviously better way to present space because—in reality—parallel lines, at least in finite form, do remain parallel.

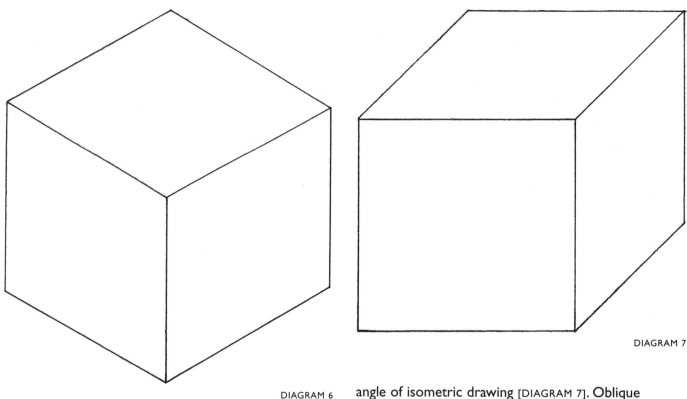

DIAGRAM 6

DIAGRAM 7

OBLIQUE DRAWING

Oblique drawing is similar to isometric, except that the frontal plane remains frontal (parallel to the picture plane), while the other planes are forced into space on a 45 degree angle rather than the 30 degree angle of isometric drawing [DIAGRAM 7]. Oblique drawing was a popular approach to rendering architectural space in historical Japanese art.

OPTIONS

Early-twentieth-century European artists, in rejecting the traditional importance of surface appearances,

FIGURE 5.11
1931 Brochure, Joost Schmidt, Bauhaus design.
(Reprinted by permission of Bauhaus-Archiv Berlin/photo Markus Hawlik. © 2007
Artists Rights Society [ARS], New York / VG Bild-Kunst, Bonn)

sculpture. These experiments led to a revolution in the visual arts, including architecture and design [FIGURE 5.11].

While Cubism is generally associated with visual art, the first "cubists" may well have been writers looking for a way to free poetry and literature from the burden of description so that words could have autonomy. Guillaume Apollinaire, Andre Gide, Gertrude Stein—these were the first writers to liberate the word from meaning in the traditional sense:

> Might be there.
> To be sure.
> With them and.
> And hand.
> And alight.
> With them then.
> Nestle.
> —Gertrude Stein,
> from *four saints in three acts*

began to challenge any and all systems of representing space. Inspired by Cezanne's use of multiple viewpoints in a single painting, artists began to tear space apart and put it back together again in ways that had never been seen before in any art—the closest thing being the geometrized African figurative

But the cubist painters were only steps behind with their wish to free painting from illusionism and linear space and to make of painting and sculpture an art as abstract as architecture.

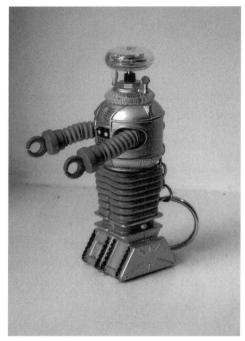

FIGURE 5.12
Toy robot.

GEOMETRY IN VERNACULAR FIGURATIVE ART

The so-called high arts of painting and sculpture are
not the only media that geometrize the figure.
Vernacular art, whether in the form of comic strips,
action figures, space travelers, or figurative trademarks,
is heavily dependent on geometry. Perhaps no people
on earth are unfamiliar with the stereotypical robot
[FIGURE 5.12], either as an action-toy or a movie

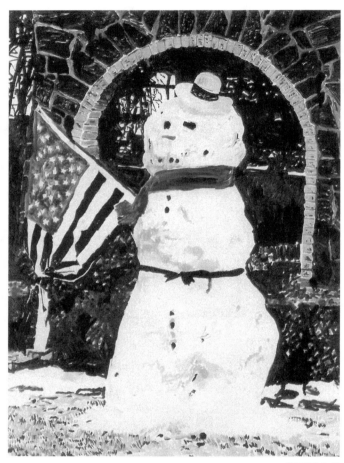

FIGURE 5.13
Patriotic Snowman, Gail Norfleet, 2001, monotype.
(Courtesy of the artist)

character—or as a real robot. And in colder climates everyone makes snowmen, and they make them with a set of conventions as universal as those that were used in Egyptian painting [FIGURE 5.13].

THE GEOMETRIC FIGURE IN CONTEMPORARY ART

Artists in the past 100 years who have worked in a geometric figurative mode are too numerous to mention: the futurists, the cubists, the collagists, the dadaists, the assemblagists—many of their works seen in this and other chapters. The American sculptor Joel Shapiro is one of the better-known contemporary artists working in a strictly geometric figurative style. In scale, his work ranges from miniatures to giants. But no matter how massive his sculptures become, they are balanced in a deceivingly precarious way: some of them jutting directly out from high gallery walls, others standing on "tiptoe" in colossal museum spaces. Shapiro's drawings

FIGURE 5.14
Untitled, Joel Shapiro, 2005, chalk and charcoal on paper, 54⅛ × 39".
(© 2007 Joel Shapiro / Artists Rights Society [ARS], New York)

probably precede his three-dimensional work. But in any case, the drawings seen alone would represent an entity, a different body of work with a subtly different voice [FIGURE 5.14].

PURE FORM

Other artists in the twentieth and twenty-first centuries have shown a single-minded devotion to geometry in pure and minimal non-referential form. Such an artist was Kazimir Malevich. Malevich, born in Russia in 1878, accomplished his finest works during the mid-teens of the twentieth century. With messianic zeal, Malevich promoted the suprematist philosophy of purest form as the ultimate goal of painting. He spoke of suprematism as the "end and beginning where sensations are uncovered, where art emerges 'as such'." His simple, severe, powerful works challenged all conventions of picture making. *Suprematist Composition: White on White* [FIGURE 5.15] painted in 1918 (forty years before minimalism) is

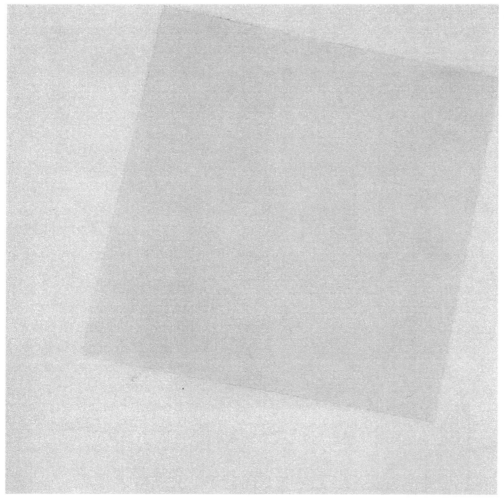

FIGURE 5.15
Suprematist Composition: White on White, Kazimir Malevich, 1918, oil, 31¼ × 31¼".
(Museum of Modern Art, New York)

perhaps his most famous work. By the late 1920s his ideas had fallen out of favor with Russia's Communist regime that considered Malevich's painting not in the service of society but done only for the sake of art. He was imprisoned for several months in 1930. After his release from prison, he sank into a period of grave self-doubt, abandoned abstraction for conservative realism, and died in 1935 at age fifty-seven.

Malevich, along with Mondrian (and De Stijl), the constructivists, the synchronists, and all the other crusaders of pure form, parented minimalism, serial art, color field painting—in other words, all the modern and

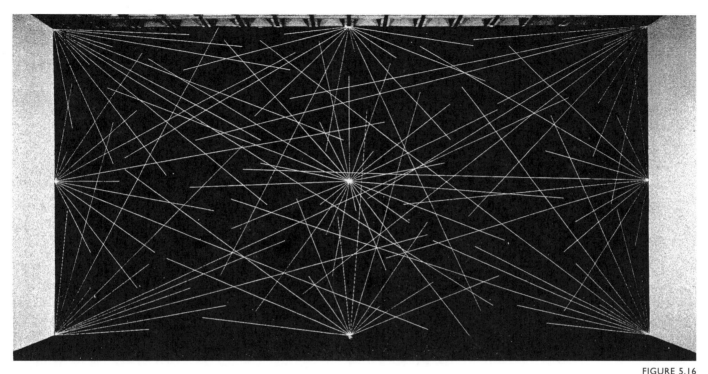

postmodern movements dedicated to geometry. In the latter groups, no one has had a greater impact on the direction of art than the graphic-designer-turned-conceptualist Sol LeWitt. Le Witt's work is testament to his insistence that the *idea* is more important than the *product*. LeWitt designed over 1,000 "wall drawings" to be installed all over the world by teams of "drawers" working from LeWitt's written instructions, thus moving drawing closer to the spirit of performing arts and architecture [FIGURE 5.16].

FIGURE 5.17
Shifting, Jaq Belcher, 2006,
hand cut paper with
graphite, 30 × 30".
(Courtesy of the artist)

We can only guess at geometry's place, if any, in the future of art. With the computer's awe-inspiring ability to layer hundreds of disparate images into one, and with photography's uncanny explorations into microcosms and macrocosms, it seems likely that a new LeWitt or Eva Hesse has already found a way to use geometry as an instrument for radical change, forging some new previously inconceivable marriage of art and numbers [FIGURE 5.17].

CHAPTER SIX
SUBJECTS

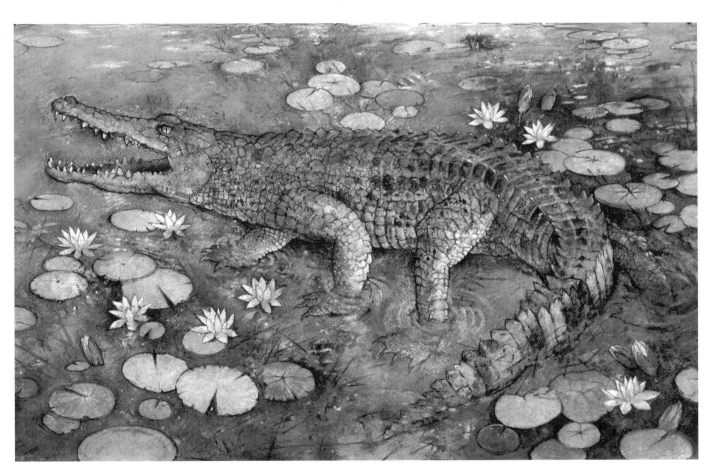

"The grand, the heroic draftsman . . . had better be the models (for artists), though one's aim be far from heroic or grand. With their august help one might learn to lay one's traps and spread one's nets, to snare the subject matter of one's own intuition and life experience, however small and special." —ISABEL BISHOP

Surely every object under the sun and every form the mind can visualize has been the subject for a drawing, sometime, somewhere. We are surrounded, inundated, by subjects, from the lowliest mechanical devices to the loftiest scenes in nature to unknown possibilities latent in the process of drawing. But a few subjects renew themselves, year after year, century after century, while others come and go like carnivals. The limited number of subjects discussed in this chapter can be seen as an attempt to present some of the self-renewing ones in high hopes that they might help us "snare the subject matter" of our own experience and intuition. Look them over. Add your own.

THE NUDE

The nude as a subject matter certainly did not originate with the Greeks. It has been used for at least 25,000 years in the form of female and male fetishes, gods and goddesses, erotic objects, and other works. History and prehistory are resplendent with examples. But the nude as a symbol of ideal beauty was indigenous to Hellenistic art. Although abandoned during the Middle Ages, the nude was resurrected in the Renaissance era and continued into contemporary times, albeit to a lesser degree. Drawing from the nude

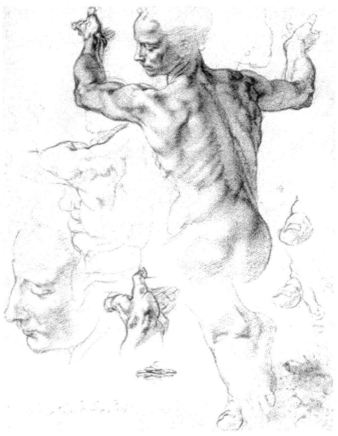

FIGURE 6.1
Chalk drawing, Michelangelo.

DIAGRAM 8

offered Renaissance artists a chance to display their drawing skills and knowledge of anatomy, thereby dazzling their audiences [FIGURE 6.1]. The study of anatomy as a viable art school subject has waned over the years. Nevertheless, many art teachers still feel that *some* knowledge of anatomy, however meager, is still essential to the study of life drawing, and that life drawing is a proving ground for any young artist, even one not interested in referential art [DIAGRAM 8].

Paradoxically, classical tradition has downplayed the sensuality of the nude, preferring an idealized version. This has been far less the case in other cultures. The artists of India, Japan, North and sub-Saharan Africa,

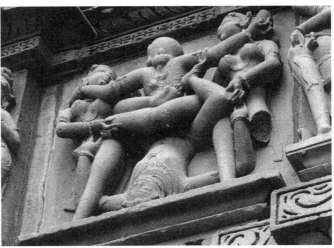

FIGURE 6.2
Khajuraho Temple, India.

and indigenous American cultures, have all reveled in the erotic—not so much as lascivious subject matter but as natural, even godly, experience [FIGURE 6.2].

THE HEAD

The head has been a subject, sometimes an exclusive subject, for artists throughout the history of art. The enormous heads of Easter Island, called "moai," still baffle us and fill us with awe [FIGURE 6.3]. The huge stone faces of the Olmec culture were carved with an anatomical correctness unknown in other parts of the Americas. The Egyptian fayyum portraits, the grand manner portraits of Western Europe, early Netherlandish portraits: all of these point to the fact that

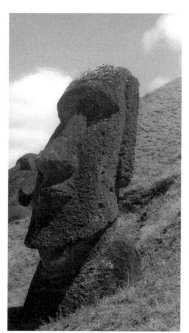

FIGURE 6.3
Photograph of moai from Easter Island.
(Photo by Elisa Shokoff)

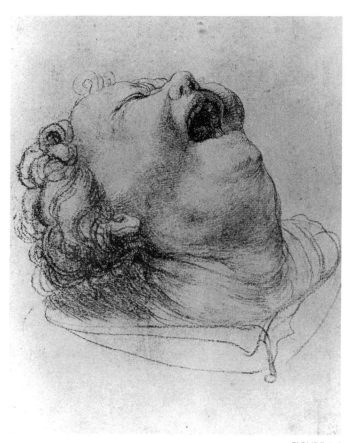

FIGURE 6.4
Crying Angel, Matthias Grunewald, c. 1515–1516, black chalk highlighted with white brush on light yellow-brown paper, 9⅝ × 7⅞".
(Kupferstich-Kabinett, Berlin)

FIGURE 6.5

Symbolic Self-Portrait with Equals, Claes Oldenberg, 1969, pencil, color pencil, spray enamel on graph and tracing paper, 11 × 8¼". (Moderna Museet, Stockholm)

the head has always been one of the world's most popular subjects for art [FIGURE 6.4, FIGURE 6.5].

Viewing the head, the part of the human figure most replete with literary symbolism, is how we recognize each other. It is difficult to draw *anything* with complete objectivity, but the head is notoriously difficult. We may be able to look at an elbow with the same detached analytical eye we use to examine a stone. But when drawing a head, we are likely inhibited by preconceptions like "facial expression" or "pretty" or "ugly." We may be able to edit a limb or two from a drawing of a tree and no one will notice. But draw one ear too large or a nose too long and you won't need an art critic to tell you the problem.

The head is a practical subject since, with the use of one or more mirrors, we can always draw our own head. In a sense, we make self-portraits no matter whom we draw because we know our features so well.

FIGURE 6.6
North Wind in March, Charles Burchfield, 1960–66,
watercolor on paper, 47½ × 59½".
(Courtesy of the Charles E. Burchfield Foundation
and DC Moore Gallery, New York)

LANDSCAPES

The great Barbizon painter Theodore Rousseau called the elements of landscape "the language of the ages," because he saw nature's qualities as eternal rather than temporal [FIGURE 6.6]. Perhaps it's the sense of the unchanging that draws many artists to nature, despite pure landscape becoming more and more difficult to find on this planet whose surface is increasingly covered with built structures. Artists who want to draw and paint landscapes often travel long distances or arrange their lives carefully to reach their subjects.

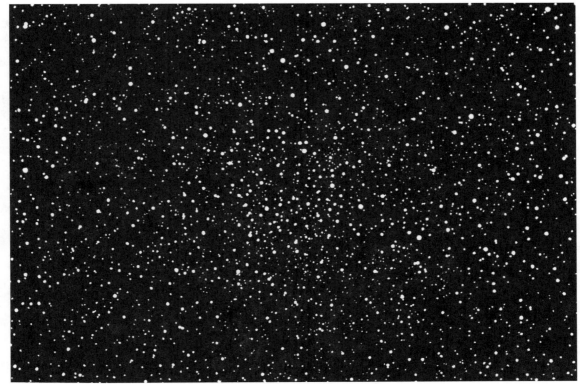

FIGURE 6.7
Star Field I, Vija Celmins, 1982, graphite on paper, 21 × 27½".
(Collection of Harry W. and Mary Margaret Anderson)

Some voices in the art world berate landscape as a hopelessly prosaic subject that belongs to the past. The landscape painter Wolf Kahn gives a tongue-in-cheek lecture titled "Ten Reasons Not to Paint Landscapes." His talk centers on the seeming inappropriateness of landscape painting in an art world that rejects it as passé. While listening to his lecture, one begins to wonder if the landscape won't be around as viable subject matter long after much of today's most fashionable art ideas are embarrassingly dated [FIGURE 6.7].

One landscape artist who has no need to travel for his subject is New Yorker Seymour Leichman. Leichman has lived for several decades in an apartment overlooking New York's Riverside Park and the Hudson River. His easel is placed directly opposite a huge window facing west. Leichman's view is never quite the same for two hours, much less two days, in a row. He keeps a steady watch on the changing seasons. Barren trees with snow-covered branches slowly give way to the fresh green leaves of spring, then summer, then fall, and back to winter, ad infinitum. His drawings have an unfathomable complexity of details that seem to flicker across the page before our eyes [FIGURE 6.8, FIGURE 6.9]. Sometimes a dog-walker or a fragment of a foot bridge or park bench finds its way into a drawing, but in context any element of the urban environment is small, overshadowed by the magnificent old trees of the park.

MORE FLORA AND FAUNA

In Jean Dubuffet's well-known lecture called "Six Anti-Occidental Positions," he challenged the civilized belief that human beings are superior to other living things, and he championed the "primitive" belief that animals, trees, rivers, and people are all of equal importance. The plethora of art inspired by natural subjects would seem to bear that out.

FIGURE 6.8
Trees in Riverside Park, Seymour Leichman, 2005, 24 × 12".
(Courtesy of the artist)

FIGURE 6.9
Trees in Riverside Park, Seymour Leichman, 2006, 36 × 24".
(Courtesy of the artist)

FIGURE 6.10
Pre-Columbian painting of man with plant, Aztec.

Flowers, potted plants, weeds, vines, fruits and fruit trees, nuts, cacti and other desert plants: all of these have been subjects for millions of paintings, drawings, and sculpture, and yet they remain as inspiring today as they were to the ancient Aztecs [FIGURE 6.10]. How obvious this becomes looking at David Bates' powerful drawing of the lowly thistle [FIGURE 6.11], or Ellsworth Kelly's simple line drawing of a flower that is a close relative to the minimal shapes of his paintings and sculptures [FIGURE 6.12], or Larry Scholder's relentless bower contained by an overall rhythm [FIGURE 6.13]. Heroic works can come from humble subjects, and heroic subjects can fall flat on their heroic faces.

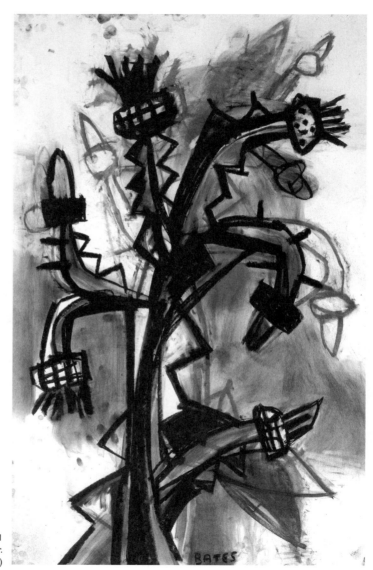

FIGURE 6.11
Thistles II, David Bates, 2000, charcoal on paper.
(Courtesy of the artist)

All of this is just as true of animal subjects. Albrecht Durer's best-known work is a portrait of a small wild animal, a hare [FIGURE 6.14]. Durer's absolute mastery of detail should not blind us to a sense of life's energy contained in the subject. Other than a date and signature, nothing distracts us here. It is our psyche and the hare's in intimate conversation.

John Alexander's portrait of a menacing crocodile surrounded by delicate water plants almost makes us shiver [FIGURE 6.15]. Without surrendering any detail, the artist has made us feel the weight of the animal and its slow determined movement through

FIGURE 6.12
Forsythia, Ellsworth Kelly, 1969, ink on paper,
29 × 23".
(Courtesy of the artist)

FIGURE 6.13
Bower, Larry Scholder, 2002 polymer relief.
(Courtesy of the artist)

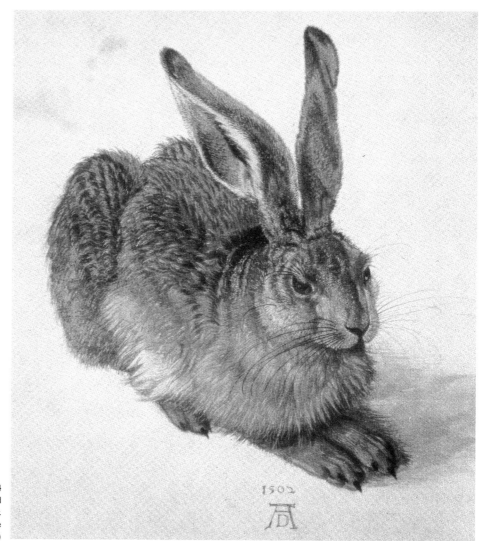

FIGURE 6.14
Hare, Albrecht Durer, 1502, watercolor and
gouache on paper.
(Reprinted by permission of the
Albertina Museum, Vienna)

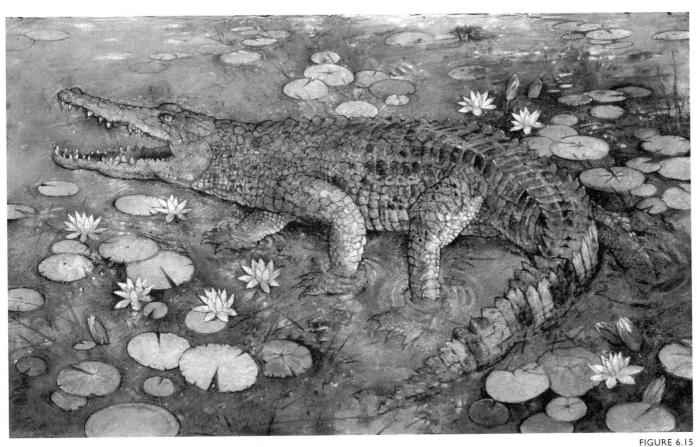

FIGURE 6.15

The Beast, Arnhem Land, Australia, 2001, John Alexander, charcoal and pastel on paper, 50 × 72".
(Courtesy of the artist and the Museum of Southeast Texas, Beaumont, Texas)

shallow water as well as its readiness for violent action. Norma-Jean Bothmer's good-hearted depiction of a monkey, looking as harmless as a stuffed toy, nevertheless communicates that this animal is our progenitor—too close to us for comfort [FIGURE 6.16]. Jim Love, in his *Raccoon on Roller Skates*, takes common pieces of scrap metal and turns them into something uncommon, indeed [FIGURE 6.17].

FIGURE 6.16
Four Monkeys, Norma-Jean Bothmer, 2005, colored pencil on canvas, 22½ × 30" each.
(Courtesy of the artist)

SOCIAL COMMENTARY

Social commentary is served well by the graphic arts. Drawing's potential for dramatic value contrasts, simplicity, directness, and, in the

FIGURE 6.17
Raccoon on Roller Skates, Jim Love, 1962, iron and steel, 7¾" high.
(Courtesy of William Hill, Houston)

FIGURE 6.18
Elsje Christiaens Hanging on a Gibbet, Rembrandt van Rijn, 1664, pen and brown ink,
brush and brown wash, 6¾ × 3⁵⁄₁₆".
(The Metropolitan Museum of Art, H.O. Havemeyer Collection, Bequest of Mrs. H.O.
Havemeyer, 1929 [29.100.937]. Image © The Metropolitan Museum of Art)

case of printmaking, the multiple/original nature, all seem to play to the needs of message making. From Goya's anguished reaction to the Spanish Inquisition to gentle Rembrandt's outrage at people's inhumanity to each other [FIGURE 6.18] to Richard Serra's alarm over the horrors generated by America's occupation of Iraq [FIGURE 6.19], artists have used graphic means to keep an eye on the human condition.

Francisco Goya had been a successful court painter in eighteenth-century Spain until he saw his fellow humans committing atrocities in the name of all that was holy. In response, he left painting behind and dedicated his work to an intensely personal print documentation of the horrors of the Inquisition. His series of prints, *The Disasters of War*, went unpublished for many years and were seen by his contemporaries as little more than caricatures. Today, two centuries later, the works are among the world's greatest art treasures.

In content, German artist Kathe Kollwitz's works often center on women: women as mothers and protectors of children, women as long-suffering survivors in a world torn apart by wars waged by men. Hers are not neutral or happy works. They are dark powerful comments on human life and its ultimate resolution in death.

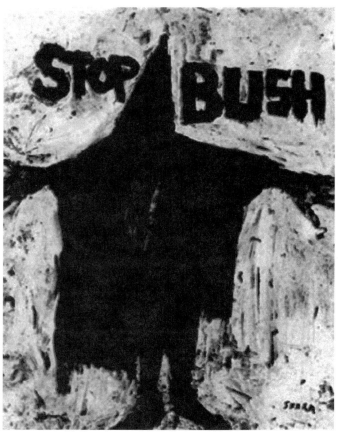

FIGURE 6.19
Stop Bush, Richard Serra, 2004, lithograph crayon on mylar, 59¼ × 48".
(© 2007 Richard Serra / Artists Rights Society [ARS], New York)

Great works can and do grow out of adversity. Nowhere does this idea seem so true as in the art of Mexico over the past century. The political leaders of Mexico have traditionally ignored the poverty and suffering of its citizens from the time of the Spanish Conquest right up to the present. At the turn of the twentieth-century, Jose Guadalupe Posada made hundreds of engravings depicting the rich versus the poor, violent events, and demons of death [FIGURE 6.20], all selling for pennies to the masses. Posada died in 1913, the year the most recent Mexican Revolution began. Not until the 1920s was his work rediscovered and seen for its true genius, his early appreciators being Mexican Renaissance artists Diego Rivera and Jose Clemente Orozco [FIGURE 6.21].

The political content in the art of Mexico paralleled the social protest artists of the United States. Artist Ben Shahn [FIGURE 6.22] was among those that documented the poverty and the racial and ethnic bigotry in America so rampant during the years between the two world wars, especially during the years of the Great Depression.

FIGURE 6.20
La Calavera Revuelta, Jose Guadalupe Posada, engraving.

Many chapters of the African Americans' heroic struggle
from slavery to equality have been documented by
great artists, but no voice has been more eloquent than
the great twentieth-century master Jacob Lawrence.
Lawrence's innate approach to art was a perfect
container for the stories he told, whether of the
migration of African Americans from South to North
or of the fruits of building as a metaphor for positive
reconstruction of a lost cultural identity [FIGURE 6.23].

The global problems of our own time have spawned
artists who are willing to use their voices to witness
deep injustices. Certainly the tortures and humiliations

FIGURE 6.23
There Are Many Churches in Harlem; The People Are Very Religious, Jacob Lawrence, 1943, watercolor and gouache on paper, Amon Carter Museum, Fort Worth, Texas. (© 2007 The Jacob and Gwendolyn Lawrence Foundation, Seattle / Artists Rights Society [ARS], New York)

FIGURE 6.24
Disco Mosul, Daniel Heyman, 2006, drypoint. (Courtesy of the artist)

American soldiers carried out on political prisoners at Abu Ghraib are well documented in the drawings and paintings of Colombian artist Botero. The graphic work of American artist Daniel Heyman drawn directly from Iraqi victims, with their words written into the works as they were spoken, is a bitter testament to the atrocities of this war [FIGURE 6.24].

DELLA STREET

"Muchachos," said Frida Kahlo, "Locked up here in school we can't do anything. Let's go into the street.

FIGURE 6.26
Dante and Virgil in Union Square, Isabel Bishop, 1932, pencil on paper, 13 × 26".
(Courtesy of the Estate of Isabel Bishop and DC Moore Gallery, NYC)

Let's go and paint the life in the street." The art world is better off because so many artists, before and after Kahlo, felt the same way. Life in the street is kinetic, Nothing stays the same for two successive seconds. The endless motion of people and animals and vehicles is accompanied by dramatic changes of light and color and a cacophony of chaotic sound. How could such energy not be a subject to artists who have the skill and will to attempt it? George Grosz, Reginald Marsh [FIGURE 6.25], Isabel Bishop [FIGURE 6.26], and Robert Birmelin [FIGURE 6.27] are artists with divergent styles but each motivated by the human drama played out in urban spaces.

FIGURE 6.27
The Mechanical Elephant, Robert
Birmelin, 2001, pencil on paper.
(Courtesy of the artist)

LANDSCAPE OF THE MIND

In Ruth Beebe Hill's book *Hanta Yo* a Lakota wise man says, "The earth owns two good days, one visible and one invisible; the earth owns two good days, one the body senses and one the spirit visualizes. The earth owns two good days, one the reasoning identifies and integrates and one the spirit desires and absorbs." These comments are a reminder of the dichotomy that often exists in individual artists. Some artists are

Looking through
two fools.
James Surls
2005

FIGURE 6.29
Looking through two fools, James Surls, 2005, ink on paper.
(Courtesy of the artist)

FIGURE 6.28
don't look at look at not, James Surls, 2005, ink
on paper.
(Courtesy of the artist)

able composers while working from life, but lack confidence when asked to work from the imagination—to create a vision. Most artists stay predominantly in one or the other of these two camps, or at least lean heavily toward approaching art from life or from the imagination even if both options are within an artist's grasp. The American sculptor James Surls is a good example of an artist able to allow the imagery of his spirit to flow uncensored into the space of a page. The following brief monograph presents some of his lines and words in synchrony and harmony.

"Who among us has found a way home to a safe here and now?"

"The snake did ok—even though he was and is hated to the teeth."

"To be Centered
is
to be

I am and am not
Is
To Be
The tree
and Know
what the tree knows."

"Thank you art.
I love you."

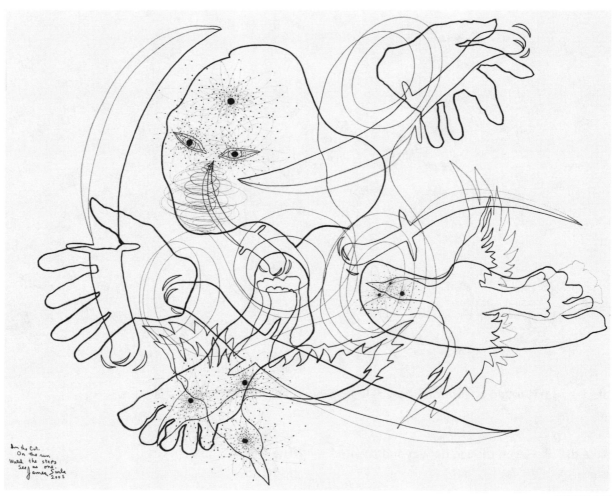

FIGURE 6.30
In the cut, On the run, Watch the steps, See as one, James Surls, 2005, ink on paper.
(Courtesy of the artist)

CHAPTER SEVEN
THE PICTURE STORY

"I was lucky to be part of the 'underground comix' thing in which cartoonists were completely free to express themselves. To function on those terms means putting everything out in the open—no need to hold anything back—total liberation from censorship, including the inner censor!" —R. CRUMB

The first story may have been a picture story; in other words, one or more drawn images accompanied by words. Certainly the picture story has been with us for many, many centuries, and it has never been more available than it is today. The market is overflowing with graphic novels, animation, comic books, comic strips, illustrated children's books, photographic essays, political cartoons. . . . It is probable that the quickening of interest in picture stories results from the intellectualizing of high art pushing those artists with traditional visual talent, that is, drawing and design skills, into more compatible fields.

THE COMICS

First of all, the comics of both past and present are not always comical. They evolved from European broadsheets made to provide the masses with moral and political propaganda. William Hogarth, the English artist, brought respectability to the kind of pictorial narrative found in broadsheets, although his followers failed to keep alive the creative fire that he started. Goya's *Disasters of War* print series transcended any serial work that had come before but was, nevertheless, a product of the tradition.

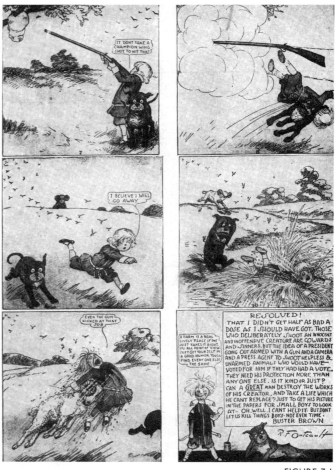

FIGURE 7.1
From *Buster Brown Goes Shooting*, R. F. Outcault, 1905.

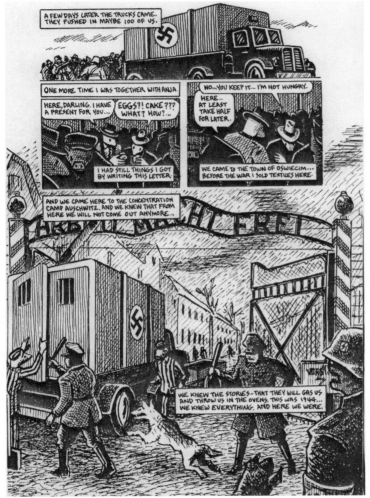

FIGURE 7.2
From *Maus: A Survivor's Tale*, Art Spiegelman, 1986.
(Pantheon Books)

Picasso loved American comic strips. But art historians and art critics have been less than generous toward them until recently, when works by comics artists—avant garde and traditional—have found their way onto the walls of some of our most august art institutions.

American newspaper comic strips, or "funnies," first flourished in the late nineteenth and early twentieth centuries, with titles like *The Yellow Kid* and *Buster Brown* [FIGURE 7.1] by R. F. Outcault, and *Little Nemo in Slumberland* by the great Winsor McCay. Comic strips' offspring, comic books, were long considered baneful presences in American culture, and this very resistance may have quickened their evolution toward a legitimate medium, often with deep social concerns. Art Spiegelman's *Maus* and *Maus II* tell the story of Spiegelman's parents' experiences in a Nazi concentration camp and their ultimate survival. In this epic tale, the Jews are portrayed as mice and the German soldiers as cats [FIGURE 7.2].

The themes of underground comics, as this now middle-aged generation of graphic books is called, range from Eric Drooker's wordless apocalyptic view of a flooded New York City [FIGURE 7.3] to Lynda Barry's bittersweet remembrance of childhood and adolescence in the midst of American culture.

Of the underground comics artists, R. Crumb is the best known and most controversial. His breadth of talent has won him critical praise and a dedicated following, including a movie biography. But his comments on grotesque human foibles, often through blatantly pornographic pictures and words [FIGURE 7.4], have deeply offended others. Crumb, as one critic put it, "weaves the line between fine 'aht' and gutter comics like a drunk taking a sobriety test."

GRAPHIC BOOKS

The popularity of the expression "graphic novels" and their availability in all parts of the planet makes it difficult to see where comics stop and graphic books begin. Perhaps the only differences are the publishing house involved, the length of the book, and the seriousness and literary ambition of the content. All will agree that *Persepolis* [FIGURE 7.5], a book about

FIGURE 7.3
From *Flood! A Novel in Pictures*, Eric Drooker.
(Published by Four Walls Eight Windows, New York/London)

FIGURE 7.4
From *The R. Crumb Handbook*, R. Crumb, 2005.
(© Robert Crumb, 2001)

growing up in Iran by MarJane Satrapi, is indeed a graphic novel. Nor is there any question that Chris Ware's *Jimmy Corrigan* [FIGURE 7.6], about a hapless character whose every effort ends in mild disaster, is a graphic novel, even though Jimmy was originally a character in an early Ware comic strip. The proliferation of graphic novels in Japan, the Middle East, the United States, Europe, and elsewhere is another clarion call at a given point in time. As always, the call is answered by emerging talents who seem to have been sitting on the sidelines, waiting to be tapped.

ANIMATION

Speaking to a group of animators in the 1920s, Winsor McCay, one of the originators of animation, said, "Animation should be an art; that is how I conceived it. But what you fellows have done to it is make it into a trade . . . not an art, but a trade . . . bad luck." Yes, Mister McCay, *but* animation's becoming a trade didn't preclude it from being an art form. Animation relied on simplicity and geometric stylizations so that frames could be drawn with greater speed. And sometimes, at least, less really is more. Characters like Felix the Cat [FIGURE 7.7], Mickey Mouse, Donald Duck, Bugs Bunny, and many other

FIGURE 7.5

From *Persepolis*, Marjane Satrapi, 2003.

(From PERSEPOLIS: THE STORY OF A CHILDHOOD by Marjane Satrapi, translated by Mattias Ripa & Blake Ferris, copyright © 2003 by L'Association, Paris, France. Used by permission of Pantheon Books, a division of Random House, Inc.)

classic 'toons' grew out of the simplicity of style that popular demand for the medium dictated. At least one of those characters, Mickey Mouse, made his way back into "high art" through works by Andy Warhol, Claes Oldenberg, and others. In fact, does a popular icon exist—including Santa Claus and Marilyn Monroe—that's more famous that Mickey? [FIGURE 7.8]

Despite the avalanche of crass cartoons that the computer age has generated, some animators who rely wholly on the computer have created mind-expanding cinema of the highest quality. However, William Kentridge is one artist/animator who has turned his

back on high technology to draw his animated films frame by frame by frame.

ILLUSTRATED CHILDREN'S BOOKS

It may be that illustrated children's books began as a sub-class of the genre of book illustration: pictorial wood engravings made to enhance literature. But with the passage of time, illustrated adult's books have fallen out of fashion while the audience for children's picture books has grown to such monumental proportions that juvenile books are now an important segment of the publishing industry. The subtle watercolor and pen and ink drawings exemplified by

FIGURE 7.8
Photo of Mickey Mouse graffiti, Roger Winter, 2007.
(Courtesy of the author)

FIGURE 7.9
Sketches for Benjamin Bunny, Beatrix Potter.
(Illustration by Beatrix Potter. Reproduced by kind
permission of
Frederick Warne & Co.)

the works of Beatrix Potter [FIGURE 7.9] have been superseded by illustrations of arresting power brought about by, among many other factors, medium exploration and advances in technology. Like all the arts, children's book illustration reflects the time in which it was made. One can't imagine the bombastic collages of Eric Carle being produced in any time other than his own. Nor can we imagine Jeanette Winter's socially challenging picture stories being products of a less tolerant world [FIGURE 7.10].

As with all professional fields, the creation of children's books remains in an evolving state. Advanced printing technologies have allowed the artists far more freedom stylistically and in terms of materials used. While many artists still prefer to work with traditional media, more and more illustrators are abandoning the drawing board for the computer [FIGURE 7.11]. But the various image-generating systems may

FIGURE 7.10
From *The Librarian of Basra,* Jeanette Winter, 2005, acrylic.
(Courtesy of the artist)

The next day, soldiers come to Anis's restaurant.
"Why do you have a gun?" they ask.
"To protect my business," Anis replies.
The soldiers leave without searching inside.
They do not know that the whole of the library
is in my restaurant, thinks Anis.

or may not be the way of things to come. The "moment" is composed of clouds, not stone, and we can never predict circumstances, technological or otherwise, that might sweep us off our feet and move us toward an unimaginable tomorrow.

FIGURE 7.11
Cover art from *The Terrible Hodag and the Animal Catchers*, John Sandford, 2006. (Boyds and Mills)

THE LEARNING PROCESS

"Drawing must be taught, and its history needs to be explicated,
and all this has probably never been more difficult than it is today." —JED PERL

FIGURE 8.1
Victorian drawing class.

The wise teacher keeps apace with changes, and finds ways to communicate new ideas. For the drawing teacher this task has indeed become more difficult in this pluralistic technological age. Once upon a time we knew what drawing meant. With pencil and paper, we tried to make a likeness of something in front of us [FIGURE 8.1]. "How to draw" books flourished and were worn out from use. But the confounding questions that caused all the art upheavals in the past 100 years eroded our confidence that drawing was worth the effort it would take to learn. After all, what *was* drawing in the wake of non-objective art?

That drawing needs to be taught is a relatively new idea, no more than a few hundred years old. People have always drawn. Drawing is possibly older than fire, but *learning* to draw was either carried out on one's own or, as ages passed, accomplished by copying from the works of a master in a master's studio. Drawing for the Egyptians was a matter of learning a body of strict conventions guiding the depiction of objects in nature. These conventions were simply not in question, and therefore changed very little from century to century. Chinese artists learned from their masters another set of conventions. An aspiring young artist was told exactly how to hold a brush, how to start and end a stroke, how to apply ink, and, in addition, the precise stroke to be used in drawing a stalk of bamboo as compared to drawing a tree limb [FIGURE 8.2]. Drawing was more closely related to the performing arts than to what we think of as creativity.

THE ACADEMY

Before the Renaissance in Italy, the idea of drawing directly from nature simply never seemed to occur to anyone. The idea of teaching drawing in an academic setting was even longer in coming. Some short-lived teaching experiments took place in Florence during the Renaissance, but it was not until 1583 when the

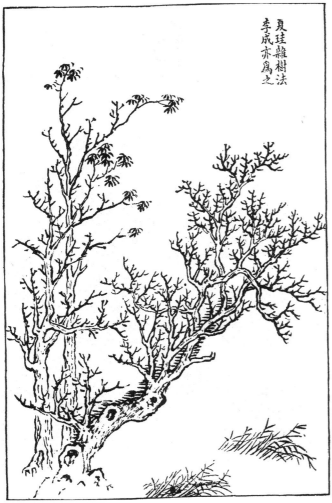

FIGURE 8.2
Drawing of a tree from *Mustard Seed Garden Manual of Painting*.

Carracci family established its academy in Bologna that the concept of drawing as a subject to be taught began to take root. The Carracci Academy, in sympathy with the Greek principle that an artist should have knowledge of mathematics, history, philosophy, music, medicine, and astronomy, promoted the liberal arts in addition to teaching drawing. Perhaps Lu Ch'ai, the Chinese brush master, embraced the same principle when he advised artists to "study ten thousand volumes and walk ten thousand miles." The American artist, Ben Shahn, seems to have been on a similar track advising young artists to learn to speak two languages other than their own. The current training of artists in universities is related, perhaps inadvertently, to this ideal of the artist as a complete person.

Sixty-five years after the start of the Carracci Academy, the Ecole des Beaux-Arts was founded in Paris. This venerable institution considered drawing to be prerequisite to study in any other medium, and learning to draw meant an arduous progression through various stages of disciplined training. First, a student drew from "the flat," meaning drawing from two-dimensional engravings of master works. Only when he (drawing was a "guy thing") had gained proficiency at this level could a student begin studying from "the round," i.e., drawing from plaster casts of

FIGURE 8.3
John Singer Sargent. *The Dancing Faun,
After the Antique,* 1873–74.
(Harvard University Art Museums, Fogg Art Museum, Gift of
Mrs. Francis Ormond, 1937.8.16. Photo: David Matthews ©
President and Fellows of Harvard College)

antique sculpture [FIGURE 8.3]. Hellenistic sculpture contained the attributes of ideal figurative proportion that a drawing student had to understand before finally being allowed to draw "from the live," meaning from nude models, typically male. This long, grueling process was well summed up by the American painter and teacher Robert Henri, a former student at the Ecole, in the following remark. "Oh! Those long and dreary years of learning to draw! How can a student after the drudgery of it, look at a man or an antique statue with any other emotion than a plumbob estimate of how many lengths of head he has." But the idea of the art academy survived and spread throughout the Western world and, in time, the East, unchallenged until the tumultuous re-ordering of values in mid-nineteenth-century Europe. The academy still survives in pockets throughout the world, seemingly undaunted by the social and technological upheavals of the past 150 years.

The Victorian educator and writer John Ruskin, despite his tyrannical rigidity ("all great art is delicate"), did challenge one of the sacred traditions handed down from the Renaissance: the already discussed concept of linear perspective. "It would take about a month's labor," Ruskin said, "to draw imperfectly, by laws of perspective, what any great Venetian will draw perfectly

in five minutes." He considered its laws "too gross and few to be applied to any subtle form." But in matters of rendering volume with light and dark, and in insisting on accuracy of vision, Ruskin didn't stray far from academic doctrine.

In America, an important challenge to the ideals of the art academy occurred in 1875 when a group of students from The National Academy of Design in New York grew restless with the school's rigid approach to teaching. The students broke away from the academy and started a school of their own that they named the Art Students League, housed in a rented studio on Fifth Avenue. At the Art Students League, the students themselves chose their faculty, and each student was responsible for the approach to learning that she or he wished to pursue. Academic drawing was still available as an option, but only as an option. The guiding principle at the League was to balance discipline and freedom, following the truism that no art is ever based on skill alone. The League students believed that any school that taught only rules had no valid place in the evolution of art. While the Art Students League is no longer the vital institution it once was, being pushed to the margin by degree granting universities, it still exists and is housed in an imposing building on West 57th Street.

THE ATELIER

The atelier method of teaching, a valuable alternative to academic training, involved an artist of some renown opening up his (or in more recent years, her) studio to a select group of aspiring artists who could then have intimate contact with the making of art. Studying in a well-known artist's atelier resembled the training of apprentices in the studios of masters. The American sculptor Louise Bourgeois is a product of the atelier approach. Quickly tiring of the rigidity of the Ecole des Beaux-Arts, she enrolled in several of the art studios popular in Paris at the time (1920s and 1930s). Her favorite teacher was the painter Fernand Leger, who saw and encouraged Bourgeois' penchant for sculpture. Such personal rapport is not likely to happen in an academic setting.

UNIVERSITY ART DEPARTMENTS

It's interesting to remember that the rise of the university art department, pushing all other methods of art training into virtual oblivion, has happened in the period of a lifetime. The shift from rigorous studio training offered in traditional art schools to the intellectual climate of a university has paralleled the

movement away from skill-based object-oriented art toward a cerebral approach where the visual object is so ephemeral that it seems little more than an appendage to the spoken or written explanation.

How causative has the university been in the intellectualizing of visual art? After all, drawing classes, if they exist at all in a university curriculum, are often considered manual training and are squeezed in between math and physical education. By the 1950's, artists and artist/teachers were well aware of this revolution that was taking place before their eyes. Many traditional art schools became affiliated with degree granting institutions as a way to compete with the university art departments' drain on enrollment and teachers. Not only potential students but also many artists were leaving urban centers to live and work or study in places like Iowa City, Iowa, or Bloomington, Indiana.

A CHALLENGE

In 1963, Mercedes Matter, a prominent New York artist/teacher and disciple of Hans Hoffman, wrote an article for *Art News* called, "What's wrong with U.S. art schools?" The article, an articulate indictment of degree granting art departments for fracturing the students' work time, and a somewhat nostalgic plea to return to uninterrupted daily drawing sessions carried out in natural skylight, was persuasive. It seemed the perfect antidote, at least to a group of Matter's students disillusioned with the programs that universities were offering, and they asked her help in forming an art school that would follow the ideals written about in her article. So Matter and her students founded the New York Studio School of Drawing, Painting and Sculpture. Though still a vital alternative to university training, the school lacks the influence of prestigious graduate departments of this time, such as Columbia and Yale.

TEACHING AND TECHNOLOGY

The impact of technologies on artists has been a revolution in itself, equaling the university's intellectualization of art. In art, as in so many fields, technology and education fit hand in glove. Elementary school children learn to layer computer-generated images, draw with a mouse pencil, print digitalized photographs, etc. If so desired, an artwork can exist only in cyberspace, and this raises a question I often hear from my artist/educator friends. Over time, what will the computer do to the tactile sense? What will happen to that semi-sacred sense of contact with

FIGURE 8.4
Education, Jan McComas, pen on paper.
(Courtesy of the artist)

materials? I'm not sure that it's worth the energy fretting over these questions. An artist or teacher's time might be put to better use through a complete immersion in the art of her or his time as well as in the history of art from all times and places so that the greatest comprehensive view can be brought to the students, wherever it may lead them. Something inexplicably wonderful exists in a vital student-teacher relationship. *This is the precious entity that must never be lost* [FIGURE 8.4].

EPILOGUE

"Le dessin est la probité de l'art."
—*JEAN AUGUSTE DOMINIQUE INGRES*

It's a common misconception to think that learning to draw is something accomplished and then filed away for future reference. It's true that our skills improve with practice, but, more relevant, drawing is a lifetime work-in-progress that shrinks and grows then disappears only to be rediscovered. To paraphrase Albert Pinkham Ryder, drawing is like being out on the end of a limb reaching for the next place. At its worst, drawing is a refuge that allows an artist to hide from greater challenges. But even then, it is of value.

For the past year, I have had the privilege of drawing from life one afternoon per week with a group of professionally experienced artists. I wish I could transport to this page the sense of total involvement, of enthusiasm, of unabashed ambition for art that emanates from this weekly gathering. We each have intense goals, but no two have similar goals. Each of us is a seeker, never wholly satisfied with what we find but never discouraged from seeking further. A younger artist may wonder what keeps us going. The answer is we have learned, as Monsieur Ingres knew, that drawing is the probity of art, the integrity of art, the honesty of art. The art critic John Russell commented that we may think we are judging a drawing, "but it can happen that the drawing is taking a measure of us. If our perceptions have atrophied or gone astray, the drawing will leave us in no doubt of it."

SUGGESTED EXERCISES

APPENDIX SUGGESTED EXERCISES

The following exercises are for those who agree with Leonardo's thought that theory should never be allowed to outstrip performance. Each of the following suggestions is meant to augment some part of the text, and while it is likely that one could profit from practicing these exercises without ever reading the text, to do so would be to deny oneself a sense of context that gives drawing its raison d'etre.

Of course, a rudimentary supply of materials is necessary before beginning. If you are in a class, your instructor will have his or her own idea of a materials list. The bare minimum would include a 2B and a 6B pencil, a kneaded eraser, a plastic bar eraser, and a 9" × 12" newsprint pad. Additional materials might include conte crayon, graphite bars, vine charcoal, compressed charcoal, a large bamboo brush, a bamboo reed pen, India ink, a ball point pen, a felt tip pen, an all-purpose 18" × 24" drawing pad, and some utility scissors and glue. As discussed in Chapter Two, one can find in this throw-away world copious drawing materials without ever going to an art supply store.

GESTURE DRAWING

Ask a model (a nude model is not necessary—members of a class can take turns posing for each other) to take an

FIGURE A.1
Gesture drawing by Kathy Windrow.

FIGURE A.2
Group gesture drawing by Mary Elizabeth Howard.

string. The line begins once and ends once. Avoid outlines. Move easily and freely from top to bottom, side to side, foot to head and back again for the full one minute [FIGURE A.1]. Draw across the model into the space of the page and even out of the page and back in again. Be excessive! Exaggerate! Distort! React! Put energy into your work! Work overall. Above all, don't start with the head and work down. This will only cause you to draw one part at a time, and end up with unrelated parts rather than a unified whole.

When the next pose is taken, start to draw immediately on a new sheet and follow this pattern throughout the session of poses. I can't overstate the importance of using a new sheet for

uninterrupted series of ten or more one-minute poses that show definite movements like reaching, striding, or bending over. When the first pose is taken, quickly move a dull 6B pencil around the page following the lines of the model's pose. Leave the pencil down on the paper and make long quick circular lines that fill the page. Avoid a scratchy, hesitant motion. Let the line flow like unwinding a ball of

each drawing, since gesture drawing is an excellent way to practice placing lines, forms, etc., within the rectangle and of overcoming fear of using the entire space.

In subsequent sessions (a session at the beginning of each class is typical) you can vary the length of poses from thirty seconds to two minutes. Any pose longer than two minutes

is apt to sidetrack you into looking for surface details rather than gesture.

Sometimes two or three models might pose together. Approach a group pose just as you do a single model pose, only look for the unifying forces that tie the figures together. Force yourself out of the center of the page and move toward the periphery [FIGURE A.2].

A helpful variation of a gesture drawing is a moving pose. Ask the model to take a series of three positions over and over like performing an exercise only at varying speeds. While the model moves, and this may be for two or more minutes, let your pencil roam following the movement. Don't try to "make a drawing." Just follow the model with your eyes and arm [FIGURE A.3].

LINE DRAWING

Place a potted plant or other organic form on a flat surface near your easel. With a 2B pencil, lightly map in the desired placement of the subject on your page. Placing is a vital part of a drawing, so take your time. When you have synchronized the subject and the page, start to draw specific shapes. Go slowly. Look for particulars. Give each area of the drawing an equal amount of time [FIGURE A.4].

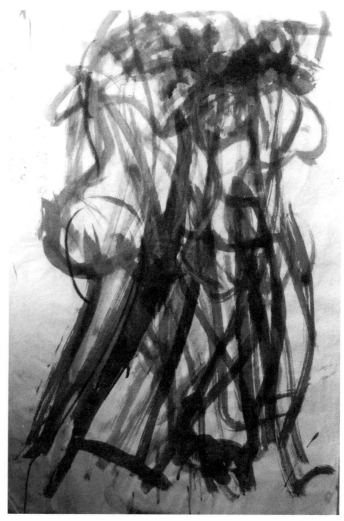

FIGURE A.3
Moving pose drawing by Marilu Gruben.

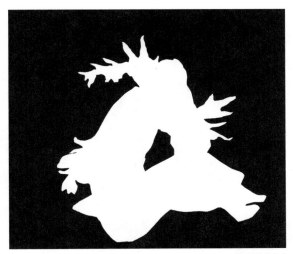

FIGURE A.5
Scissor cut by Margaret Brinson.

When drawing one side of a leaf (or an apple or a person) compare it with the opposite side. Don't generalize. Look for subtle details. Try different subjects using the same approach. A single line drawing encourages a commitment that builds confidence.

The most unequivocal line that can be used is cut with scissors. One can't miss the relationship between this approach and the precise, searching pencil line that I have described above. Vary the length of time you spend on a cutout drawing from five minutes to thirty minutes [FIGURE A.5].

FIGURE A.6
Value drawing by Jonah Winter.

VALUE

Value can be measured. Drawing and design teachers often assign a value scale project expected to show the range of values through gradations of light and dark bands. This is a helpful exercise because it allows one to see the degree of control that is possible when drawing values. A good follow-up project would be to make twenty-minute studies of a side lit model or object while reducing the values used to a specified number: three or four [FIGURE A.6]. You will begin to see that lights and darks fall into amorphous patterns of shapes, and that to use these shapes in your drawing will bring a sense of solidity.

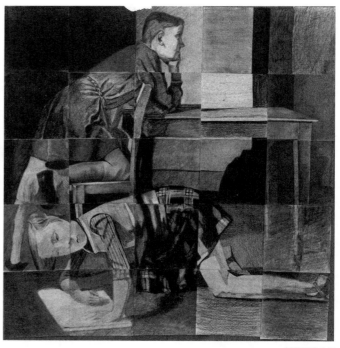

FIGURE A.7
Class project in measuring values, pencil study of The Children, Balthus, each square 4 × 4".

For a class project in measuring values, here is an idea: Cut up a well-known painting into as many squares as there are people in a class. Number each square and indicate which side is the top. Each person's task will be to make an accurate value study of his or her square. Each square should be the same size, done with the same medium (perhaps a 2B pencil) on the same paper type. The values in the study should exactly reproduce the values in the assigned

square. No one needs to know what their square represents, since this might hinder objectivity. When all have finished their squares, the teacher can reconstruct the original painting by pinning up the squares in their original places [FIGURE A.7]. Squares with "off" values will look out of place in the reconstruction. These off values may be redrawn until the transitions throughout are smooth.

DRAWING LETTERS

Choose a simple font from the computer or other source and write a short word using either upper or lower case versions of this font. Then with pencil and paper, make a careful copy of your word 8" high or more. Strive to get all the proportions correct. Pay special attention to the spaces around and between the letters; the "ma." Don't bother filling in the letters. Just leave the work a pure line drawing [FIGURE A.8].

A GROUP DRAWING

Pin up a large sheet of paper or several sheets pieced together. The teacher can choose a subject for a drawing. The subject can be specific, like a street event, or generic

FIGURE A.8
Numbers 0 Through 9, Jasper Johns, 1967–1981, brush and ink over unique etching proof, 13 × 9¾".
(© Jasper Johns / Licensed by VAGA, New York, NY)

FIGURE A.9
Group drawing.

like four figures in a landscape. Then each student, using any materials at hand, takes turns working on the drawing for five to ten minutes. Ideally, the drawing will move from general to specific, from structural to pictorial, but there may be stages where the work becomes confusing and has to be turned upside down or on a side so new marks of orientation can be drawn. Regardless of the nature of the end product, this can be a liberating project since no one person is fully responsible for the drawing [FIGURE A.9]. It's also a fine spectator sport.

DRAWING FROM ART

Two years ago I spent part of each vacation day drawing from Pre-Columbian art on display in a museum in Mexico [FIGURE A.10]. Prior to this experience, I had drawn some from kachina dolls and other objects in the Museum of Indian Art in New York. Otherwise, I had thought of drawing from art as drawing from "the masters" of European and American painting, and then only in the form of quick compositional studies [FIGURE A.11]. The great drawing teacher Kimon Nicolaedes stated unequivocally that students should make six compositional studies from art each day for four years. I am now convinced that there is profit to be gained from making studies of any worthwhile art object from any culture. Drawing from the Pre-Columbian figures brought me into intimate contact with the subtlety of the forms; a contact that would have been

difficult to achieve in any other way. I have not had the chance to test this approach in a teaching context, but I am convinced of its value for me.

STUDIES OF THE HEAD

Van Gogh once set himself the task of drawing and painting fifty heads in a specified period of time. A visiting artist once told my drawing class they should draw a self-portrait each day for thirty days. Such a focused project is always helpful if, for no other reason, it lets an artist know what to do—like any series. And of course there is always

FIGURE A.10
Study of Pre-Columbian art, Roger Winter, pencil.
(Courtesy of the author)

FIGURE A.11
Study of Winslow Homer's *Breezing Up*, Roger Winter, pencil.
(Courtesy of the author)

FIGURE A.12
Mary Myers, James Dowell, oil on paper, 30 × 22".
(Courtesy of the artist)

FIGURE A.13
Jaime, James Dowell, 2000, oil on paper, 30 × 22".
(Courtesy of the artist)

*benefit and challenge in such demanding observation. The
painter and filmmaker James Dowell began an open-ended
project several years ago of making paintings on paper of
the people who are important in his life [FIGURE A.12,
[FIGURE A.13]. I don't know if he has surpassed Van Gogh's
count, but I do know that the project is still underway.*

SOCIAL COMMENTARY

*Pick a topic that has currency and that you have deep
concerns about and make a series of drawings ramifying
that topic [FIGURE A.14]. Or make a series of drawings of
people of a racial or ethnic group not your own.*

FIGURE A.14
War Games—Spain, Regina Granne, 2003, pencil on paper, 4 × 6".
(Courtesy of the artist)

SYMMETRY

On a square sheet of paper, make totally symmetrical drawing. For a study like this [FIGURE A.15], it would be beneficial to make preliminary studies from Islamic tile design.

PLAY

All work and no play makes Jack, or Jill, a dull artist. To play is to make your own work, to use your own voice never looking over your shoulder. To play is to "dance like nobody's watching." The results of play can be criticized, but the critic will need more universal words than those used for most classroom work. To play means to turn loose of a structured routine for the sake of self-renewal. Play helps create a dialog with a medium and with the imagination. An artist makes discoveries while "playing" that wouldn't be possible through any other means.

For anyone who might have trouble getting started, here's a suggestion: Leave your house or classroom and go to an

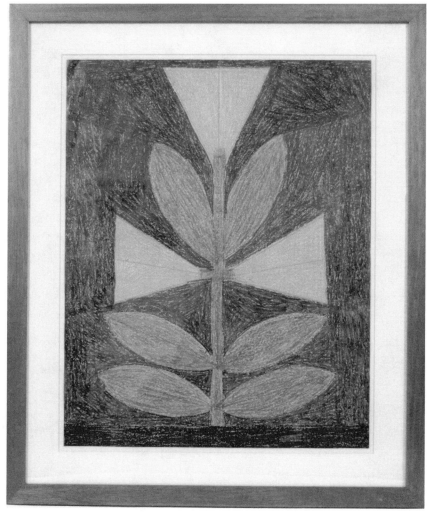

FIGURE A.15
Drawing of plant, Eddie Arning, oil crayon on paper.
(Collection of Selig and Angela Sacks, New York)

unfamiliar, or at least not too familiar place. Walk around without a plan. Try to remember as much as possible of what you see—people, architectural details, animals, landscape elements, signs, the way people dress and what they do, automobiles, bicycles, and so forth. Go back to a private place where you can draw, bring out all the drawing materials you have, and start putting down all that you can remember. Forget composition. Forget what you have done before. Be rough with your materials. Forget appearance. Let the drawing be ugly, clumsy, childlike, silly. Break all the rules and make up new ones. Be an iconoclast. Remember that this is your drawing and that no one else needs to see it or approve of it. Want to make a comic strip? Here is your chance.

GLOSSARY

Anti-occidental: Opposition to the Western values inherited from the ancient Greeks by way of the Italian Renaissance.

Architectonic: The unifying structural design of an art object.

Broadsheet: A large sheet of paper with printed material on one side.

Charcoal: Vine charcoal refers to vines that have been bundled, inserted in a metal tube, and burned to form a drawing material. Compressed charcoal is a drawing material made from concentrated charcoal dust held together with a binder.

Ch'i: The spirit of life that Chinese artists hope to infuse into their works.

Color field: A form of non-objective painting that puts great emphasis on color and has minimal interest in form.

Conceptual (as opposed to perceptual): The quality of visual imagining rather than direct observation.

Constructivism: a non-objective art movement started in Russia that puts total emphasis on organization of spatial elements.

Conte: A dry, hard-drawing material sold in small bar-shaped sticks. Its capacity for creating tones makes it appropriate for value studies.

Cross-hatching: A method of creating light and dark by laying a series of lines drawn in one direction over a series in a different direction.

Cuneiform: Writing done in wedge-shaped characters.

Curator: A museum employee responsible for arranging and overseeing exhibitions.

De Stijl, or "the style": A 20th-century Dutch school of painting that relied on rectangular forms arranged asymmetrically and painted in the primary colors plus black and white.

Disjunctive space: Space that is fractured, not linear.

Ephemera: That which is not meant to last.

Extant: That which still exists.

Fayum portraits: Egyptian faces painted in a style influenced by Roman art.

Font: Any of the various styles of forming letters of an alphabet.

Form elements: The abstract elements (shape, line, texture, color, etc.) that comprise a work of art.

Futurism: An early 20th-century art movement that tried to give form to the dynamics of movement.

Graphite: The mineral used in pencils which is also sold in bar and stick form.

Hatching: A method of creating values by drawing a series of parallel lines; often associated with pen and ink.

Hellenism: Devotion to the values of ancient Greek culture, i.e., reason, knowledge, moderation, and physical development.

Hieroglyphics: A system of writing in pictures often associated with ancient Egyptian writing.

Impasto: Thick applications of paint.

Linear space: Space that is not disjunctive.

Metalpoint: An approach to drawing done on prepared surfaces (gesso or other matt primer) with sharpened points of silver, gold, or other metals.

Minimalism: A spare, impersonal, often geometric approach to art.

Multiple original: A characteristic of printmaking; hence, each print in a numbered edition is considered an original.

Non-referential art: Art with no reference to appearance of anything in visible nature.

Pastels: Prefabricated colored chalks formed by binding dry pigments with one of many possible binders, creating sticks of drawing material.

Petroglyph: An image carved or pecked on a rock, usually associated with prehistoric cultures.

Pictograph: A drawing or painting on a rock wall.

Picture plane: The two-dimensional plane of a page, canvas, etc., on which one's idea is created. Reference to the picture plane usually implies the importance of the retention of the quality of two-dimensionality with which one starts.

Placement: The placing of a line or form in relation to the periphery and space of the picture plane.

Play: An approach to renewal or discovery through an unstructured, irresponsible attitude toward making art. To play is to let things happen.

Psychical distance: The distancing of oneself from an artwork so that its aesthetic quality can be perceived. Examples of aids to psychical distance are picture frames, sculpture pedestals, the theater stage, and the model stand, none of which has much currency in avant-garde approaches.

Runes: Alphabetic characters used by Germanic people during the Middle Ages.

Sfumato: The softening of edges, especially in drawing, by blending through rubbing with the fingers or with a great variety of tools.

Suprematism: An early 20th-century Russian art movement relying on totally flat geometric forms.

Ukiyo-e: A Japanese tradition of woodblock printing from the 17th through the 19th centuries. With flat areas of color and simple, graceful lines, these prints celebrated everyday life of the Japanese people.

Vertical perspective: A means of picturing space by placing faraway objects above middle-ground objects and middle-ground objects above objects in the foreground.

INDEX

Page references in *italics* indicate a figure on the designated page.

mandalas, 51–52, *52*
Marsh, Reginald, *86,* 87
Mary Myers (Dowell), *124*
masks: African, 9, *9;* primitive, 55
mathematics, influences on art, 6–7, 10
Matisse, Henri: cut paper works of, *32,* 33;
 Reclining Nude Seen from the Back, 15, *15; The*
 Snail, 32
Matter, Mercedes, 110
Maus: A Survivor's Tale (Spiegelman), 95, *95*
Maus II (Spiegelman), 95
McAgy, Douglas, 10
McCay, Winsor, 95, 97
McComas, Jan, *111*
The Mechanical Elephant (Birmelin), *88*
medieval period: illuminated books produced in
 era of, 42, 43, *43,* 44; influences of
 Christianity during, 6, 7–8
The Medieval Sketchbook of Villard de Honnecourt, 6
Mesopotamia, early writing in, 38
metal, in assemblage, 33–34, *34,* 35, *35*
metalpoint, 131
Mexican Revolution, 83
Mexico, art of, 83, *83*
Michael (Granne), 26
Michelangelo: chalk drawing by, *68;* on drawing
 from nature, 7, 8; gifts for patrons and friends
 of, 14
Mickey Mouse, *93,* 97, 100, *101*
minimalists, 56, 131
minimal non-referential form, 63–66
moai of Easter Island, 70, *70*
mobiles, 35
modular units, 23, *23*
Momento Five (Tuttle), *35,* 36

Mondrian, Piet, 64
Monroe, Marilyn, 100
montage art, 29–30, *30*
moving pose drawing, *118*
multiple original, 131
Museum of Indian Art, 122
Mustard Seed Garden Manual of Painting, 107

naïve, art of, 3
Nakagaki, T. Kenjitsu, *42*
National Academy of Design, 109
Native American drawings, 18, *18*
Nazi concentration camps, art related to, 95, *95*
negative space, 26, 121
neoconstructivism, 56
New Mexico, petroglyphs in, 5, *5*
New York Studio School of Drawing, Painting
 and Sculpture, 110
Nicolaedes, Kimon, 122
Nomurajima, Hiromi, 22, *22*
non-referential art, 131
Norfleet, Gail, *Patriotic Snowman* by, 62
North Wind in March (Burchfield), 72
nude, as subject for drawing, 68, *68,* 69, *69,* 70

oblique drawing, 60, *60*
Oldenberg, Claes, *71,* 100
Olmecs: hieroglyphics of, 38, *38;* naturalism in
 art of, 6; stone faces carved by, 70
op art, 56
Orozco, Jose Clemente, 83, *84*
Ostracon of Senenmut, 14
ostraka, 14, *14*
Outcault, R. F., *94,* 95
outsider art, 3

ABOUT THE AUTHOR

Roger Winter taught painting and drawing at Southern Methodist University for twenty-six years. Among his past students are nationally recognized artists John Alexander, David Bates, Stephen Mueller, and Robert Yarber. Winter has had five solo shows at the Fischbach Gallery in New York and has shown at galleries and museums throughout the country. His work is represented in many notable public and private collections. In 2007, Winter received the Contemporary Legends Award for his contribution to contemporary art in Texas.

Robert Birmelin Drawing from Life (detail),
Roger Winter, 2007, oil on linen, 21 x 24".